Boston
all one family

PHOTOGRAPHS BY BILL BRETT

Text by CAROL BEGGY • *Foreword by* ROBERT B. PARKER

COMMONWEALTH EDITIONS • BEVERLY, MASSACHUSETTS

ISBN-13: 1-978-933212-16-6
ISBN-10: 1-933212-16-0

Second printing, November 2005

Library of Congress Cataloging-in-Publication Data
Brett, Bill, 1945–
 Boston : all one family / photographs by Bill Brett ; text by Carol Beggy.
 p. cm.
 Includes bibliographical references and index.
 ISBN 1-933212-16-0
 1. Celebrities—Massachusetts—Boston—Portraits. 2. Portrait photography—Massachusetts—Boston. 3. Brett, Bill, 1945– I. Beggy, Carol. II. Title.
 TR681.F3B74 2005
 779'.2'0974461—dc22
2005015094

Cover and interior design by
Stephen Bridges

Printed in Hong Kong

Commonwealth Editions
266 Cabot Street
Beverly, Massachusetts 01915
www.commonwealtheditions.com

Jacket photo: Boston Mayor Thomas M. Menino (center) and his predecessors, former mayors Raymond L. Flynn (left) and Kevin H. White, gathered for this photograph in the Public Garden. With more than 40 years of Boston leadership between them, the three mayors have led the city in very different times and have faced very different challenges, but each has continued to be a strong voice for the city and its people.

FOREWORD

For Bill Brett a city is its people, and for forty years he has been assembling a portrait of Boston, person by person, face by face. He likes to say that these are pictures of people who make a difference, but in his heart, I suspect, Bill Brett believes everyone makes a difference, and he photographs them as if they did.

There is no place in the city that Bill has not been, no gathering of Bostonians that Bill has not photographed. He is not a man who covers catastrophes, or moments of high drama that fade in the next day's sunlight. Rather he has recorded the ongoing life movement of the city in the faces of politicians and debutantes and ballplayers and hackies, street kids, and chefs, philanthropists, cops, and, when there was no one else, an occasional novelist. Bill is not the open shuttered eye on celebrities, though he has photographed many. His subject is nothing less than humanity, in its Boston incarnation. Where there is something happening, Bill Brett is there with camera, quiet, never intrusive, hold it just a second, thanks. The picture is taken and the human occasion preserved. Candid, informal, momentary. And yet there is something in the camera, and in Brett, that gives these pictures dignity and formality, and endurance. They are pictures we wish to look at long after their moment has passed.

It is what art does, after all. It frames and preserves and dignifies the onrush of life so that we may revisit it at our leisure, and, perhaps, if the picture is just right, savor it in a way we were too busy to do in the moment.

How does Brett do this when others do not? I do not know. It is the puzzle of art. Something in the process, surely; something in the eye, of course; but finally, something in the imagination of one man, that is lacking in another. I have no explanation…Either, finally, you believe in magic or you don't.

Robert B. Parker
May 2005

The inimitable **Smoki Bacon** and her husband and partner in the social scene, **Dick Concannon**, were a power couple before anyone thought to coin the phrase. Famous for their stories and for knowing what's going on in the Back Bay and on Beacon Hill, the couple even have their own public-access television show. Known for garnering more buzz than ratings, *The Smoki and Dick Show* developed into a must-watch for those who want to know how the other half socializes and what's being talked about in Boston.

Born and raised in Boston, **Benjamin Crowninshield Bradlee** (right) served as executive editor of the *Washington Post* from 1968 to 1991, its years of national ascendancy. He is best known for leading the paper's coverage of the Watergate scandal, which led to the resignation of President Richard Nixon. With his brother and sister, Ben grew up a mostly proper Bostonian on Beacon Street. He attended St. Mark's School in Southborough, where he contracted, and beat, polio. **Ben Jr.** is working on his fourth book, a biography of Ted Williams that will be published by Little, Brown. He resigned from the *Boston Globe* in 2004 after 25 years at the paper. As a reporter, he served on the Spotlight Team, with the State House Bureau, and as the paper's roving national correspondent. As a deputy managing editor, Bradlee oversaw the *Globe*'s Pulitzer Prize–winning coverage of the sexual abuse scandal in the Catholic Church.

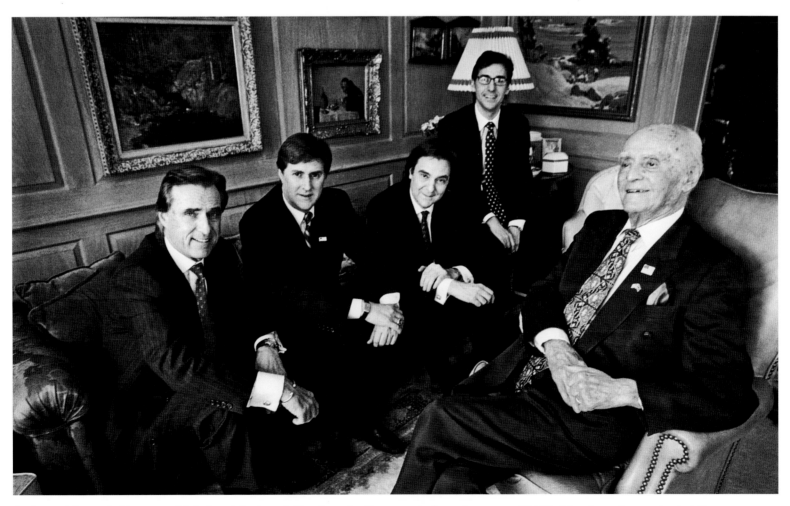

Anthony Athanas held court at his beloved Anthony's Pier 4 on the Boston waterfront the way an Old World ambassador received visitors. All who entered the now legendary restaurant were greeted as though they were the highest-ranking government official (many were exactly that) or the biggest Hollywood star (Elizabeth Taylor once tried to talk Anthony out of a few of his chairs, legend holds.) His sons, **Anthony Jr.**, **Michael**, **Robert**, and **Paul**, now run the operations. Until their father passed away in early 2005, he was still a frequent visitor, keeping watch on the details that gave the restaurant its worldwide reputation.

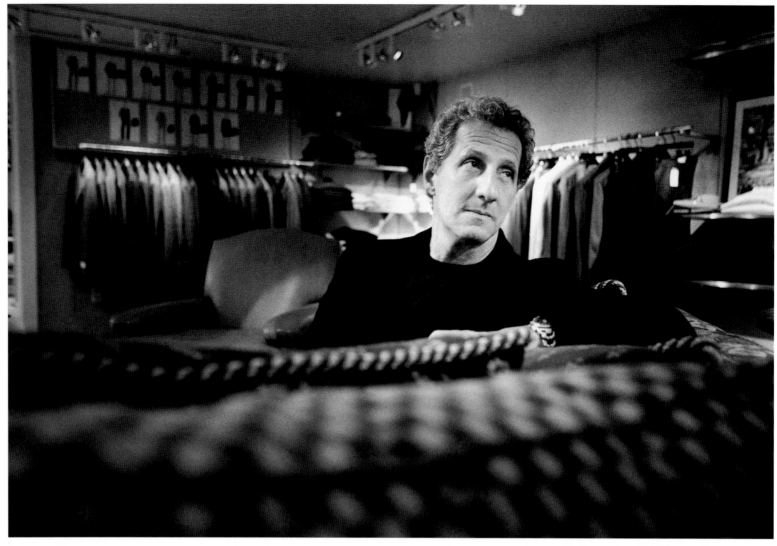

Notoriously fussy. Eclectic. Fiercely loyal. Intensely focused. The very words some business owners work hard to keep out of descriptions about themselves, men's fashion designer **Joseph Abboud** embraces. Once voted by his Roslindale High School classmates as "best dressed," Joseph was known for his style but wasn't looking for a career in fashion or design. He thought he'd be a well-dressed teacher. Then, as he tells it, one day he walked into Louis Boston on Newbury Street (where he is pictured above), and his life was changed. He worked at the store before starting the company that bears his name. Although now he spends more of his time elsewhere on the East Coast, Joseph is known to jump in his car and drive up for a Red Sox game or make a serendipitous visit to his old haunts. "I'm truly locked in Massachusetts," he told a reporter in 1997. "I've lived in Paris and New York, but I keep coming home. I guess I'll always be a Bostonian."

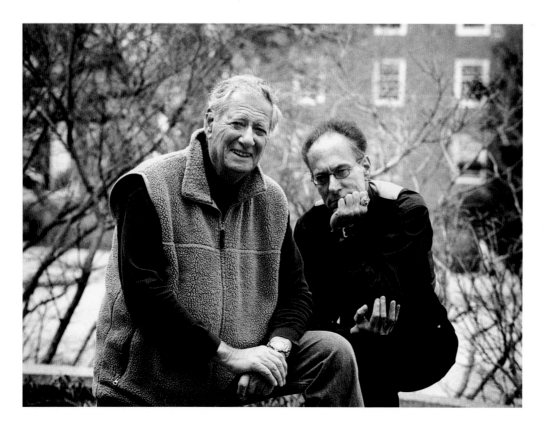

Writer-critic-director **Robert Brustein** founded the American Repertory Theatre in 1980, leaving Yale for Harvard. He built the ART into a world-renowned theater company before turning the reins over to visionary director **Robert Woodruff** in 2002. Brustein is now listed as "founding director and creative consultant," but one word that cannot be applied to him is "retired." His book *Letters to a Young Actor: A Universal Guide to Performance (Art of Mentoring)* was released in early 2005, and he writes regularly for various publications. Woodruff hasn't been sitting by quietly. By the first quarter of 2005, he had nearly 20 productions under his belt with a new ART facility, the Zero Arrow Theatre, fully up and running.

State Representative **Jeffrey Sanchez**, City Councilor **Felix D. Arroyo**, and State Senator **Jarrett T. Barrios**—the first Hispanics elected to their respective offices—found a small gap in their schedules to have their photograph taken in front of this mural in Hyde Square. But when the three arrived, there were just moments of daylight left, requiring some quick thinking. Several cars were rearranged so that their headlights would serve as background lights. Just moments before the shot, Sanchez and Barrios moved to put Arroyo in between them as a sign of respect. "We're where we are because of Felix. He paved the way," said Sanchez.

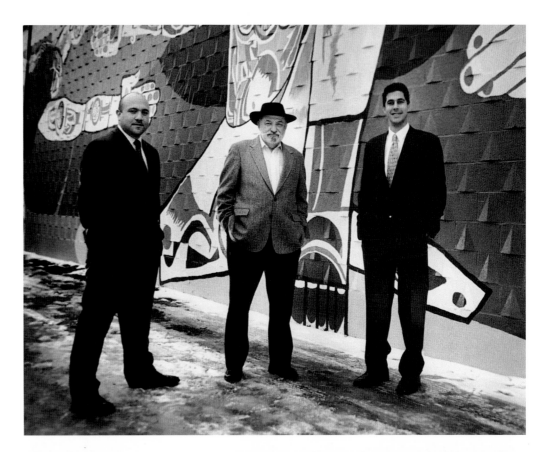

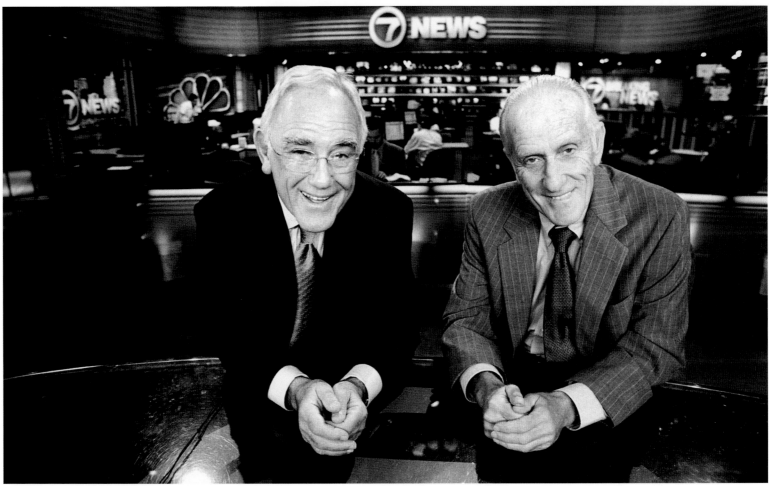

Born in Worcester, raised in Athol, brothers **Ron** and **Ed Ansin** actually began their business careers in Florida, where their father moved the family and transformed their shoemaking operations into a real estate empire. In Miami, a young Ed Ansin took over a fledgling television station and invented the rat-tat-tat style of TV reporting now known as Miami-style news. After Ed purchased Channel 7 in Boston in 1993, the family officially returned home to its New England roots. Sometimes controversial, Ed deflects critics with a simple nod to the station's high ratings. But there's no questioning the family's generosity. Among the region's largest donors to the United Way, Ed and Ron, a former state commerce commissioner, sold a piece of land and donated the entire $2.6 million from the transaction to the Boys & Girls Clubs of Boston and the Boston Youth Service Providers.

Before anyone had declared a "War on Poverty," there was Action for Boston Community Development. As president and CEO of the anti-poverty group, **Robert M. Coard** oversees an agency that provides direct services to more than 100,000 low-income people each year. Among the ABCD programs that attract such large numbers are Head Start, Summer-Works, an alternative high school, and welfare-to-work programs, Adult Literacy and Skills Training Program, and a two-year program through Urban College of Boston, which now awards the Robert M. Coard Scholarship with the support of Endicott College in Beverly.

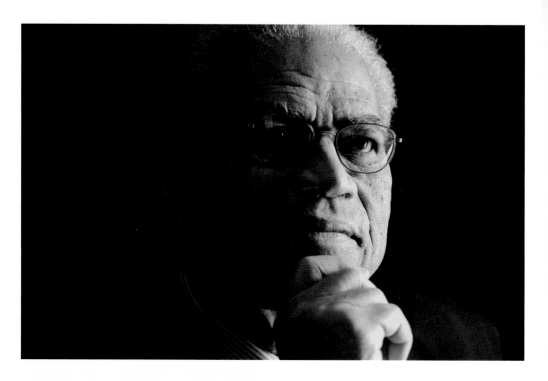

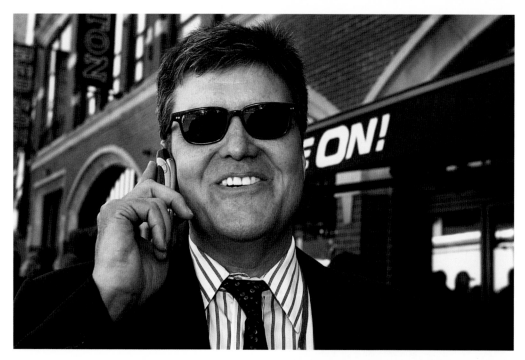

There was a time when **Patrick Lyons**'s day was beginning just as everyone else in the city was ready to unwind. But now, with a family-friendly bowling alley and restaurants at the Mohegan Sun casino in Connecticut among the 32 entertainment venues Patrick's company, the Lyons group, operates, he's more of a mainstream businessman. When Game On!, the company's newest site, opened in a corner of Fenway Park just up the street from the flagship nightclub Avalon, Patrick was still handling a few last-minute arrangements as guests arrived on the Red Sox' opening day.

As executive director of the Democratic National Convention Committee, **Julie Burns** had to make sure everything ran smoothly and that Boston looked its best in the summer of 2004. She faced the added challenges of heightened post–9/11 security amid expectations of a city gearing up to welcome its junior U.S. senator as the Democratic nominee. When Julie, who was serving as Mayor Thomas M. Menino's chief of staff, was tapped by her boss to oversee local operations, she said she "believed the city would rise to the occasion." She was right.

Steven Belkin is the founder of the privately held company Trans National Group, which has its headquarters in Boston. Steve's also the owner of the Atlanta Hawks NBA basketball team, the Atlanta Thrashers NHL hockey team, and the arena where both squads play their home games. But most Bostonians know that among the many things Steve and his wife, **Joan**, keep in balance is their support of many causes in the Boston area and beyond.

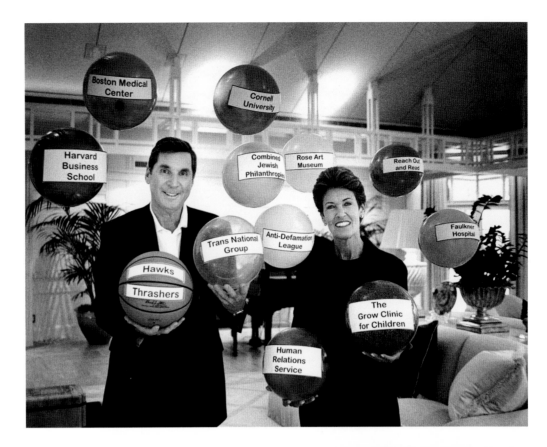

Roger Berkowitz, president and CEO of Legal Sea Foods, is often up and about before dawn, looking over operations at his state-of-the-art South Boston processing facility as fishing boats begin to bring in their catches. Only then does he head to one of the company's 31 restaurants, which dot the Eastern Seaboard from Massachusetts to Florida. When he took over the family business there were five eateries in the company, always packed with patrons, including the anchor restaurant in Park Square. When Roger moved that centerpiece restaurant across the street, he signaled a rebirth of this revitalized section of Boston.

When **Richard H. Gilman**, right, was named publisher of the *Boston Globe* in 1999, he became the first person outside the Taylor family to run the newspaper since 1873, the year after its founding. Since **Martin Baron** was named editor of the *Globe* in 2001, the newspaper's staff has won two Pulitzer Prizes, including the Public Service Journalism medal for the paper's ground-breaking investigation of clergy sexual abuse in the Roman Catholic Church. Richard has served on numerous boards and is the president of the Commercial Club of Boston. In 2004, Marty was named Editor of the Year by the National Press Foundation.

From the Harvard College gridiron to the Boston skyline, **Donald J. Chiofaro** has left his mark on the city. A bruising linebacker and businessman, Don's $600 million, 1.8-million-square-foot International Place has been designated by the *Wall Street Journal* as one of the top ten office buildings in the country.

Rev. J. Donald Monan, SJ, and **William M. Bulger** spent decades running some of Boston's most important and powerful institutions. When Father Monan took over as president of Boston College in 1972, the school's endowment was reported at $5 million; today the college Father Monan now serves as chancellor has an endowment topping $1 billion. After 35 years as a leading state lawmaker, which included serving as Senate president from 1978 to 1996 (the longest such tenure in state history), Bill Bulger was inaugurated as president of the University of Massachusetts system, a position he held for nearly eight years.

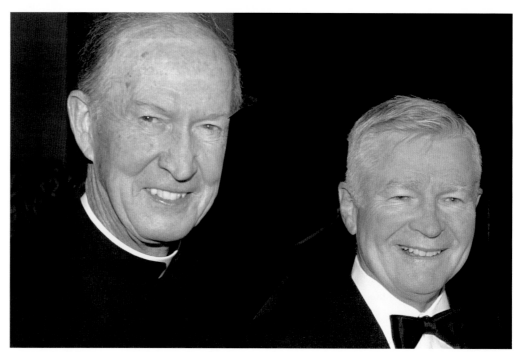

It's not a coincidence that **Lee Berk**, the now-retired president of the Berklee College of Music, and the institution he ran for more than 25 years seem to share a name. Berk's father, Lawrence, who founded the school in a townhouse on Newbury Street in 1945, reversed his young son's name and gave it to the program he started for those wanting to study jazz. Now a college with a spectacular array of music programs and a notable list of alumni, Berklee is as much a part of Boston as its nearby collegiate neighbors, Northeastern, Emerson, and Boston University.

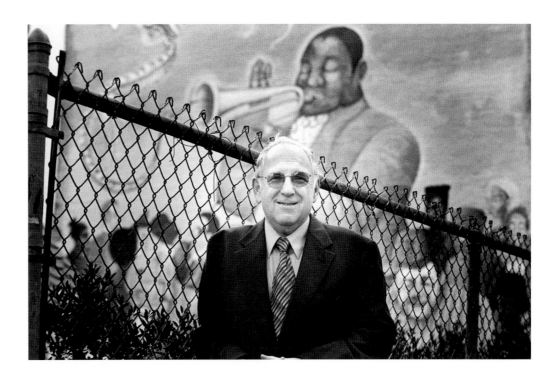

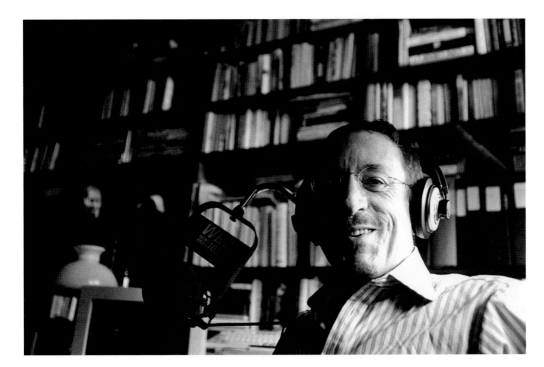

The late WBZ-AM talk show host, **David Brudnoy**, posed for his portrait at the studio in his Back Bay home where he broadcast the show for some 10 years after revealing he was HIV-positive. Bill Brett took David's photograph in the fall of 2003, the day before David began treatment for Merkel cell carcinoma, the disease that would ultimately take his life in late 2004. The scholarly Brudnoy had many titles: talkmeister, libertarian, author, professor, and movie critic chief among them. He once said he liked best whatever he was doing at the time—but it seemed the thing he cherished the most was communicating.

After spending most of his life in public service and receiving many awards, including Legislator of the Year, **James T. Brett** says one honor stands out above the rest: having Brett House in Dorchester, a community home for disabled adults, named for him and his family, who hail from the same neighborhood. "They did it just as I was leaving the Legislature," said Jim, who served as a state rep for 15 years. He added, "I'd like to think it's named for the whole family," which includes Bill Brett. For the past decade, Jim has served as president and CEO of The New England Council, New England's oldest regional business organization.

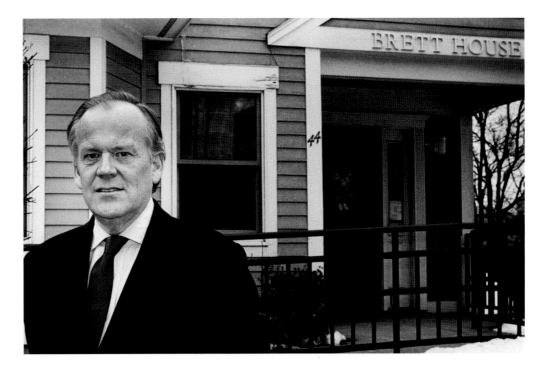

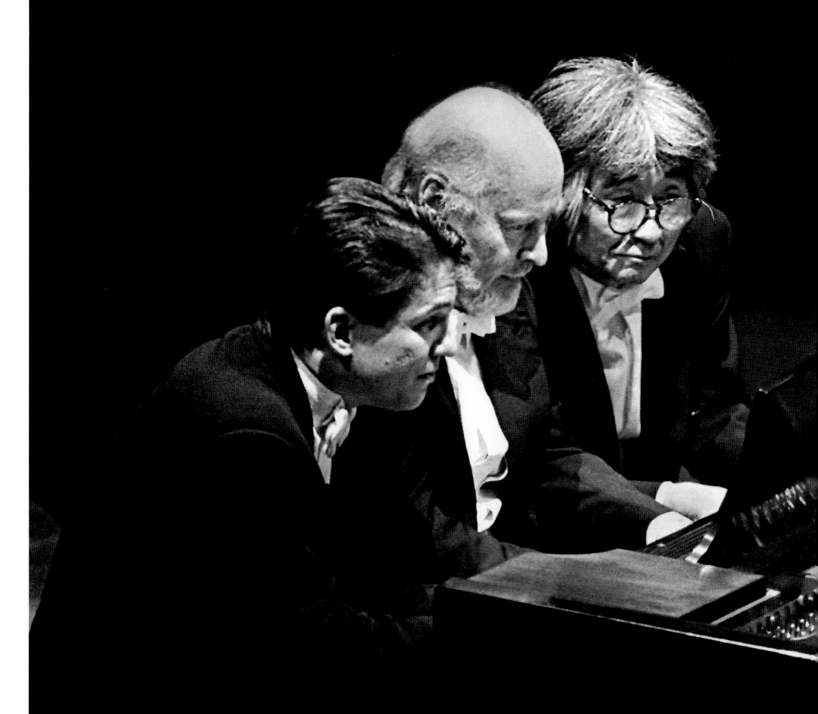

It's rare to see three conductors on stage at the same time, even rarer to see them playing together at the piano. Those who saw the trio of Boston Pops conductor **Keith Lockhart**, Pops conductor emeritus **John Williams**, and the Boston Symphony Orchestra's **Seiji Ozawa** play at the Centennial Concert talk about the scene with the same reverence and enthusiasm as those who witnessed Red Sox legend Ted Williams hit a home run in his last at-bat at Fenway Park (a fitting bit of fanaticism given the maestros' devotion to the Red Sox). The historic concert was at Symphony Hall in 2000, when Ozawa was still music director.

A partner with Brown Rudnick Berlack Israels, **Cheryl M. Cronin** is the rare attorney who specializes in government relations: she can work both sides of the aisle with equal ease. Named by Mayor Thomas M. Menino as general counsel to Boston 2004, the host committee for the Democratic National Convention, she has also worked for Republican acting governor Jane Swift on the Massachusetts Turnpike Authority. Prior to entering private practice, Cheryl served as the legislative counsel to the state's attorney general and was general counsel to the state's Office of Campaign & Political Finance. A member of the Massachusetts Convention Center Authority, she's involved in several civic causes and has co-chaired the American Heart Association's women's luncheon and the Heart Ball.

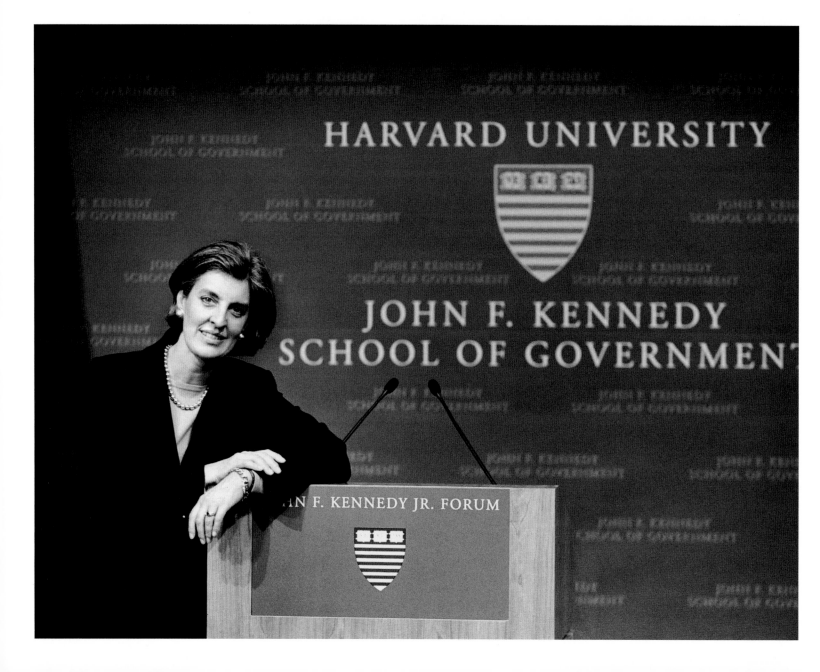

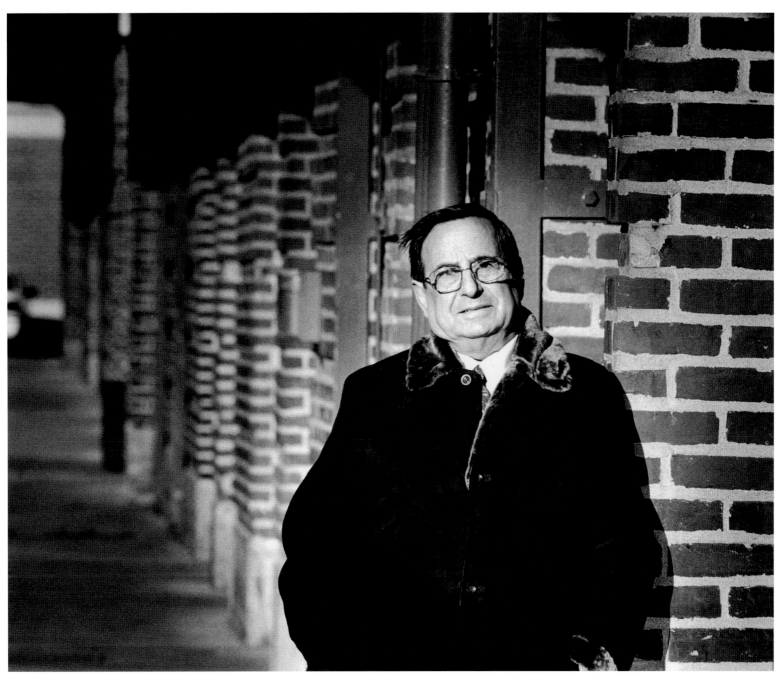

(opposite) **Heather Pars Campion** has worked the corridors of power for the Democratic Party from Capitol Hill to the White House. She is Group Executive Vice President and Director of Corporate Affairs at Citizens Financial Group, Inc. Before joining Citizens in 1998, Heather was associate director of the Institute of Politics and director of the Forum of Public Affairs at the John F. Kennedy School of Government, Harvard University.

He had no fancy airs about him, and only the most observant visitors knew that **Nicholas J. Contos** was the owner of the No Name Restaurant on the Fish Pier on the South Boston waterfront. His charitable efforts were like his physical presence and even his famed eatery's name: very understated. "No one who approached him for any kind of help was turned away," said the Rev. Dr. Emmanuel Clapsis, dean of the Holy Cross Greek Orthodox School of Theology in Brookline, after Nick's death. "He was the most extraordinary person I have ever met."

The philanthropic father and son team of **Herbert F. Collins** and **Christopher W. Collins** are the co-founders of Collins Nickas & Company, which focuses on the acquisition and preservation of existing affordable housing. Previously, they were chairman and managing partner of the Boston Capital Corporation, a real estate investment firm that controlled more than $8 billion in real estate assets and owned properties in 48 states.

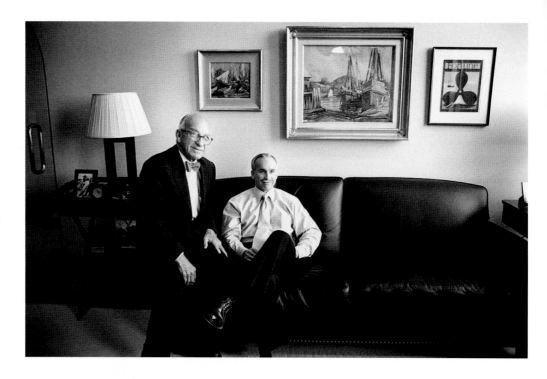

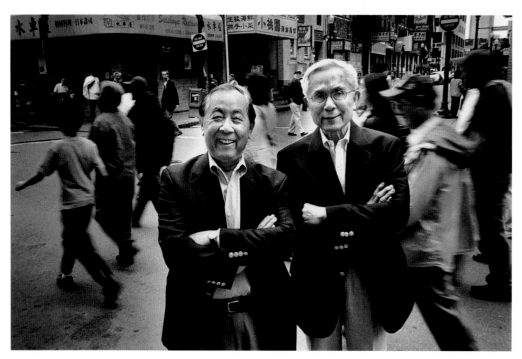

For decades, **Bill** and **Frank Chin** have guided the stoic political world of Boston's Chinatown. Bill, who runs the neighborhood landmark China Pearl Restaurant, and Frank, now retired as the city's purchasing agent, have managed quietly to achieve government services for their neighborhood faster than any special committee hearing or blue-ribbon panel.

Brothers **Robert** and **William Cleary** are best known for leading the U.S. hockey team during the first "Miracle on Ice" at the 1960 Winter Olympics in Squaw Valley, California. At the height of the cold war, the U.S. team defeated the Soviets for the first time and went on to capture the first gold medal the United States had ever won in hockey. Raised in Cambridge, Billy and Bob attended Harvard (Billy, '56; Bob, '58).

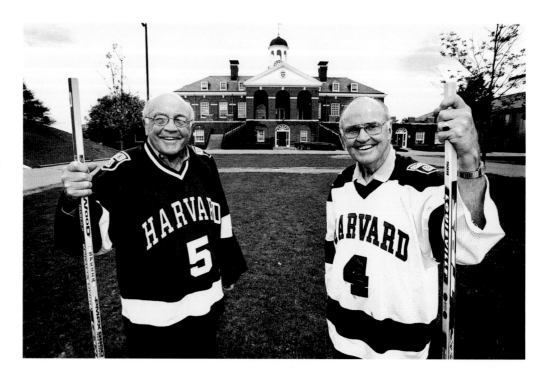

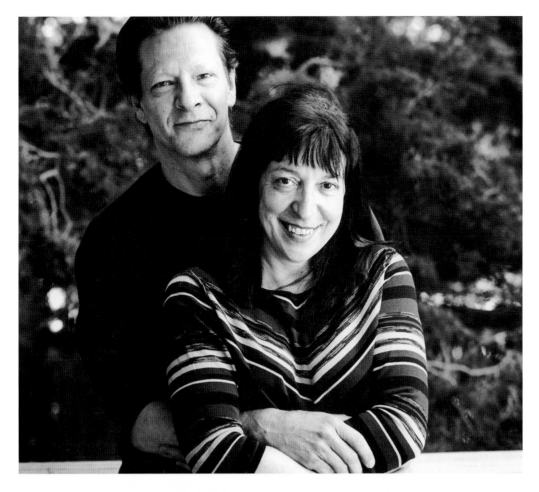

He's the Oscar-winning star of *Adaptation* and *Seabiscuit*. She's best known as an actress-writer featured on *The Sopranos*. But **Chris Cooper** and **Marianne Leone Cooper** have always seen themselves as artists who were primarily parents working on behalf of their son, Jess Lanier Cooper. Jesse, 17, died in early 2005 of sudden unexplained death in epilepsy. The Coopers moved to Kingston, Mass., from New York City so that Jesse would have access to more programs and could attend public schools. "It really was all about Jesse for us. We both came to love it here because of him," said Marianne, a native of Newton. The couple has started the nonprofit Jesse Cooper Foundation to help families with disabled children benefit from public programs. The foundation also supports AccesSportAmerica, which helps the disabled through high-challenge sports.

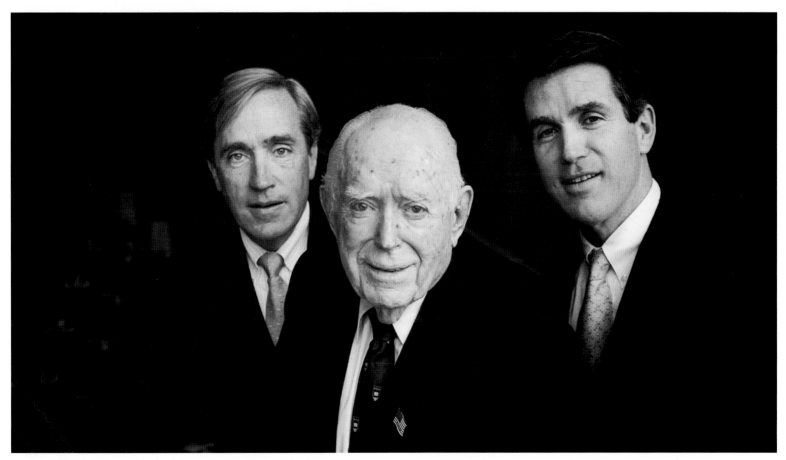

On the occasion of his birthday, 400 Boston area bankers turned out to serenade **Frank Brennan,** founder and former chairman of the Massachusetts Business Development Corp. and former president of the Union Warren Bank. The family's long tradition in the world of banking and finance is continuing. Frank's son **Thomas F. Brennan,** left, was a senior vice president with Fleet Bank, now part of Bank of America. Son **John J. "Jack" Brennan,** right, is the chairman and CEO of the Vanguard Group. In 2002, when Jack was a guest speaker at Bentley College, his father attended the lecture and they both received a surprise: an honorary degree for Frank, who had studied at Bentley but left to fight in World War II and never graduated.

When **Kevin Chapman** ran Boston's film bureau, he made sure people making movies in the city had everything they needed. But the acting bug had bitten him, and he left his hometown and full-time job for Los Angeles and the uncertainty of a career in Hollywood. "People think I went from Boston right into movies," said Kevin, who toiled for several years in odd jobs while auditioning for roles. He now has 16 feature film credits to his name including *Mystic River, Ladder 49,* and *21 Grams.* He has also appeared on television, with recent appearances on *24, Joan of Arcadia,* and *Boston Legal.*

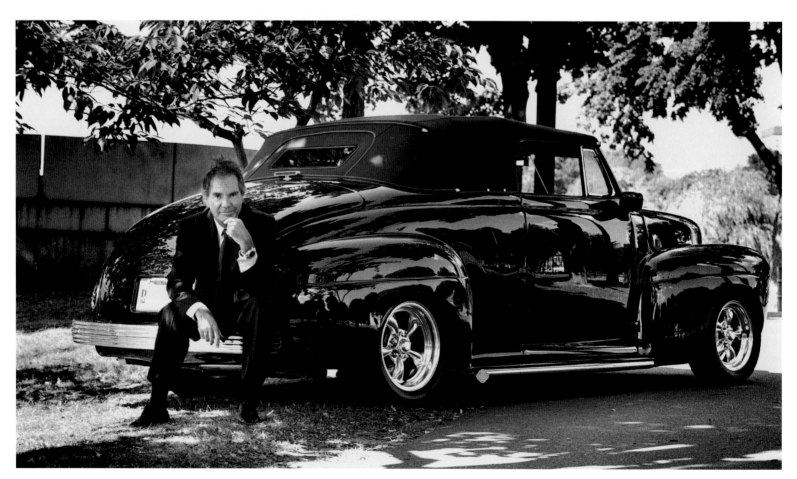

He is New England's largest auto dealer, a title **Herb Chambers** seems to take seriously. No snowflake or errant leaf can mar the image of Herb arriving at a charity fundraiser or at a dinner with friends at Davio's in a spotless Mercedes Maybach. It's as if the outside world knows this is one of Herb's cars or yachts and just moves on to something else. Herb's 1941 Ford convertible is an example of another thing he is known for: good design plus speed. This photograph was taken on the Esplanade along the Charles River.

When **Jim Cotter** stepped down as the head coach of the Boston College High School football squad at the end of the 2004 season, it was the end of an era. During his 41 years of running the program from the sidelines, Cotter had led the Eagles to 35 winning seasons and chalked up 232 wins, including two Super Bowl championships. Never were the successes of his tenure as obvious as when three dozen of his captains and co-captains came together to honor their coach, mentor, and teacher. But Cotter, a Savin Hill native, hasn't ended his 44-year tenure at the Catholic boys' school; he's now a special assistant to the school's president, Bill Kemeza.

Since 1981, **Matt Siegel**, right, has held court every weekday morning on powerhouse radio station WXKS-FM, "Kiss-108." Trends in music have changed countless times and other morning shows and personalities have moved on, but *Matty in the Morning,* with intrepid entertainment reporter and newsman **Billy Costa**, has stayed the course. The two started at the station in the earliest days of Kiss-108, and they have prevailed despite ownership changes, the growth of other media, and the advent of new technologies.

Suffolk County Sheriff **Andrea J. Cabral** seemed to come out of nowhere when she arrived on the scene, and she has defied description since taking office. Once a Republican, she switched parties, seeking a greater voice in shaping policy. She fended off an election challenge that many in the county thought she couldn't handle. When invited to speak at the annual South Boston St. Patrick's Day breakfast, Andrea didn't shy away from the spotlight; instead, she left the packed house laughing and thinking about what she had said. In 2005, Andrea missed that breakfast out of respect following the tragic death of one of her off-duty corrections officers, Sergeant Richard Dever, who was stabbed trying to break up a fight outside a Charlestown pub. The Sheriff's Department and its officers continue to be among the largest contributors to city causes, whether delivering collected clothes to churches or sending support to U.S. troops stationed overseas.

Louis B. Casagrande became president of the Boston Children's Museum in 1994 and has been guiding children to serious fun ever since by providing a museum experience that helps kids understand and enjoy the world in which they live. An author and editor, Lou has served on the boards of Citizens Schools, the Boston Arts and Business Council, the Irish Children's Museum in Dublin, and other civic organizations.

He's Boston's chairman of the board. When the *New York Times* was reporting a story about how Bostonians were dealing with the aftermath of the Catholic Church sexual abuse scandal, the paper called **Jack Connors Jr.** Jack is a founding partner and chairman of Boston-based mega-marketing firm Hill, Holliday. Among the company's clients are John Hancock, Dunkin' Donuts, and Anheuser-Busch. Jack serves as chairman of the board of both Partners HealthCare System and Dana-Farber/Partners CancerCare. He also chairs the board at his alma mater, Boston College, is chairman of the board of Fellows at Harvard Medical School, and is a trustee of Brandeis University.

Boston's Fire Department proudly claims the honor of being the nation's first paid municipal fire department, dating its efforts back to 1678. Today, Commissioner **Paul A. Christian**, left, leads some 1,700 firefighters and civilians and oversees a budget of $120 million. In a proud Boston tradition, the department's leadership has most often worked its way up through the ranks, knowing every detail of the city and the department. Joining the commissioner in this photo are his predecessors, **George Paul**, **Martin E. Pierce Jr.**, and **Leo D. Stapleton Sr.**

Middlesex District Attorney **Martha Coakley** gained international fame in 1997 as the prosecutor in the trial of British au pair Louise Woodward, who was eventually convicted of manslaughter for killing an eight-month-old baby in her care. Coakley, the first woman elected as a district attorney in the state, has earned a reputation as a tough prosecutor in a county with one-quarter of the state's population.

Dr. Michael F. Collins, a clinical professor of internal medicine at Tufts University School of Medicine, is the former president and CEO of Caritas Christi Health Care System. In a decade under his leadership, Caritas, with six hospitals, grew into New England's second-largest health network. In mid-2005, Michael was named chancellor for the Boston campus of the University of Massachusetts.

Micho Spring has spent her career at the nexus of business, politics, and civic leadership in Boston, and has helped shape public debate on a great many issues. Born in Havana, Cuba, Micho first came to Boston to attend Harvard's John F. Kennedy School of Government. It was then that she fell in love with Boston, and she has been here ever since. She worked for Boston Mayor Kevin White, first as chief of staff and later as deputy mayor for policy. She moved into public relations, and today is chair of U.S. corporate practice for Weber Shandwick Worldwide, the world's largest public relations agency.

With all the charitable and civic organizations Ernst & Young's **James S. DiStasio** belongs to and all the causes to which he has given a helping hand, you'd think he was a lifelong resident of Boston. But Jim's connection to the area began in 1994, when he came from the Midwest to serve as managing partner of Ernst & Young's New England–area offices. Jim held that Boston-based position for 10 years before being named Ernst & Young America's chief operating officer. Organizations he has worked with include the Massachusetts Business Roundtable, the United Way of Massachusetts Bay, and Catholic Charities.

Boston sports fans always grumble about owners who are too involved— but they also grumble about those who aren't involved enough. Boston Celtics managing partners **Robert Epstein**, **Wyc Grousbeck**, and **Steve Pagliuca** have walked that line by investing heavily in the team's basketball operations, launching a high-impact philanthropic venture, and letting their "basketball people" run the team. That doesn't stop the owners, most visibly Grousbeck (also the team CEO), from playing superfan at home games. Their Boston Celtics Shamrock Foundation, which assists New England youth organizations, has been an impact player off the court.

To say that attorney **Gloria Cordes Larson** has been under public scrutiny is an understatement. Not too many envied her as chair of the Massachusetts Convention Center Authority, when it wasn't clear when the Boston Convention & Exhibition Center would open—or, when it did, whether the beloved Hynes Convention Center would have to close. But when the new convention center—the largest building ever built in New England—opened, Gloria was the toast of the town. A Republican in a sea of Democrats, she was the toast of the Democratic National Convention for getting the South Boston facility opened in time to host the media party.

There are two kinds of newspaper readers in Boston: those who admit they read the *Boston Herald*'s "Inside Track" and those who don't admit to it but actually do. Following the death of longtime *Herald* gossip Norma Nathan in 1991, **Gayle Fee** and **Laura Raposa** teamed up to write the popular column that appears in the paper six days a week. Known as the Track Gals, as well as other less flattering names they wear as badges of honor, both are veterans of hard news. Gayle was a *Herald* city editor and Laura a business scribe before they started the column in January 1992. There are two kinds of people who get calls from the Track Gals—those who can't wait to dish and those who wonder what they did wrong.

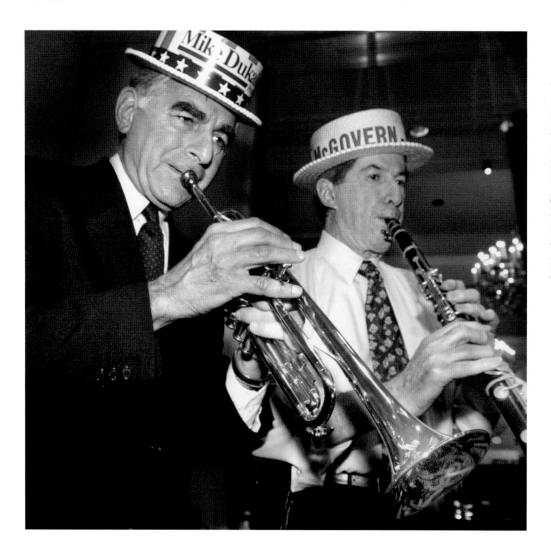

Governor. Democratic presidential nominee. Advocate of public transportation. Professor. Adviser. And don't forget trumpet player. It was the first time in 30 years that **Michael S. Dukakis** had played the trumpet in a concert, he told those gathered. But being a good sport, Mike took up the horn at a 2003 gala to benefit the Boston Classical Orchestra at the Langham Hotel and played with **Don Lipsitt**, father of the orchestra's music director, Steven.

The story of State Auditor **A. Joseph DeNucci** has many chapters. There's Joe the former Golden Gloves champ who boxed more matches in the old Boston Garden than any other fighter. There's the state representative of 10 years. And then there's the man who has been auditor since 1987, whose more than 4,200 audits have identified more than $2 billion in "unnecessary and unallowable costs and uncollected revenue owed to the Commonwealth." The net result of those findings has been millions in savings for the state's taxpayers.

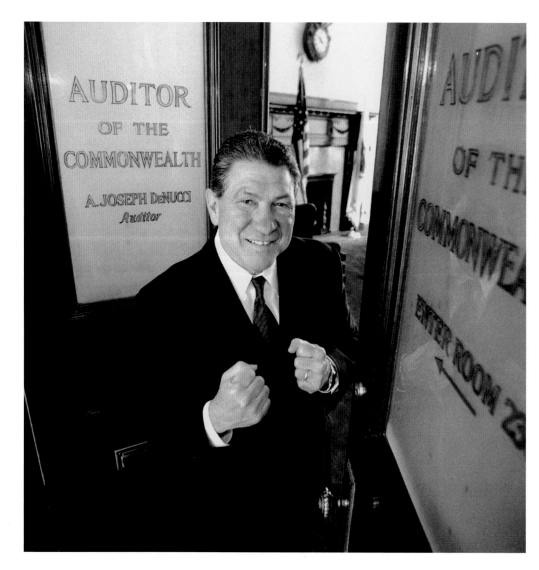

Donna DePrisco is known as much for being the doyenne of diamonds in Boston as for her charitable work in the region. Classically trained in piano, Donna is a member of the boards of prominent local institutions, including the Boston Public Library, the New England Conservatory, Catholic Charities, and the Museum of Fine Arts. Her philosophy: "It's not your aptitude but your attitude that gives you altitude."

(overleaf) **Stephan Ross** was a 14-year-old prisoner at Dachau when US soldiers liberated the concentration camp in 1945. "If I turned out anything like what people would call normal, it's because of those heroes," he says. Stephan became a psychologist and has counseled residents of housing projects in South Boston and Dorchester. His face—and a shirt bearing the number once tattooed on his arm—is reflected in the New England Holocaust Memorial, the Congress Street landmark he worked to establish.

Although **Gururaj "Desh" Deshpande** sits as a member of the Corporation of the Massachusetts Institute of Technology and, along with his wife, Jaishree, donated $20 million in 2002 to the college, he's not an alumnus of the school. Rather, he donated funds for the creation of the Deshpande Center for Technological Innovation because, he said, MIT is a place where ideas can be translated into innovative companies and products. Desh also established a mechanism for supporting entrepreneurs and young companies through seed and research grants. He founded the Chelmsford-based Sycamore Networks Inc. in 1998, and has a litany of successes in starting up technology firms.

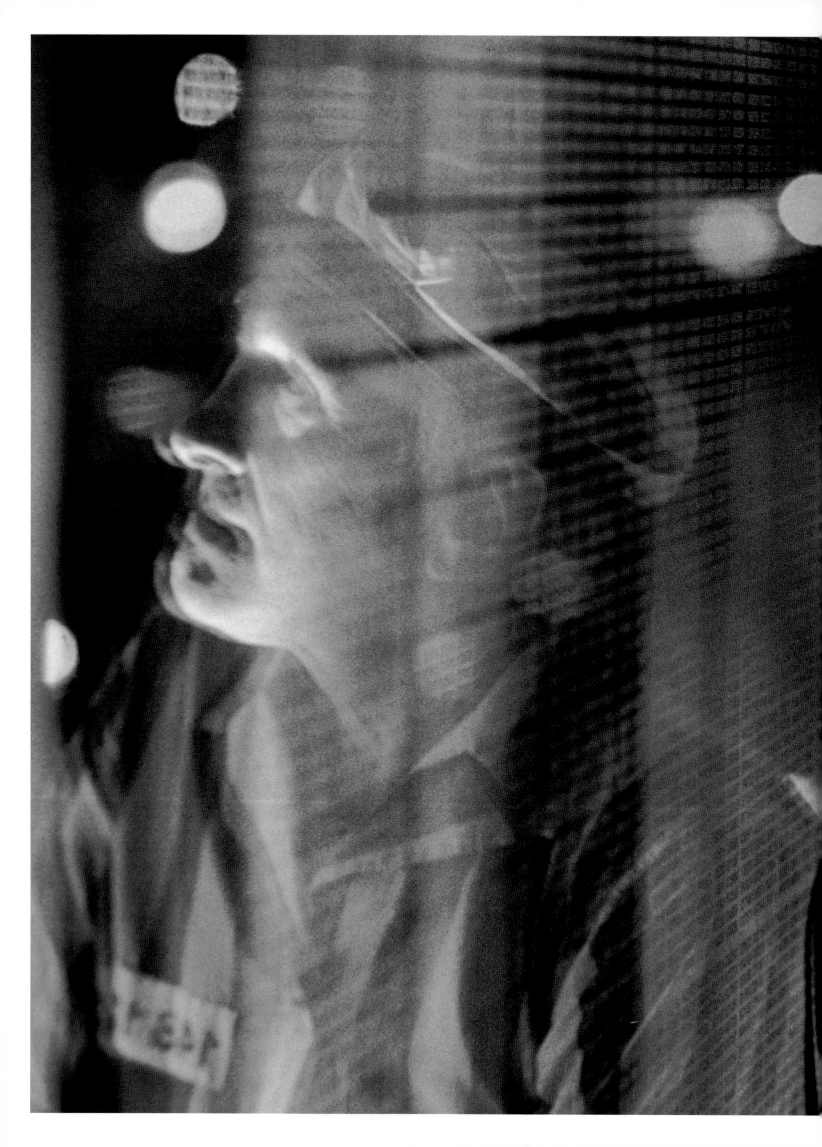

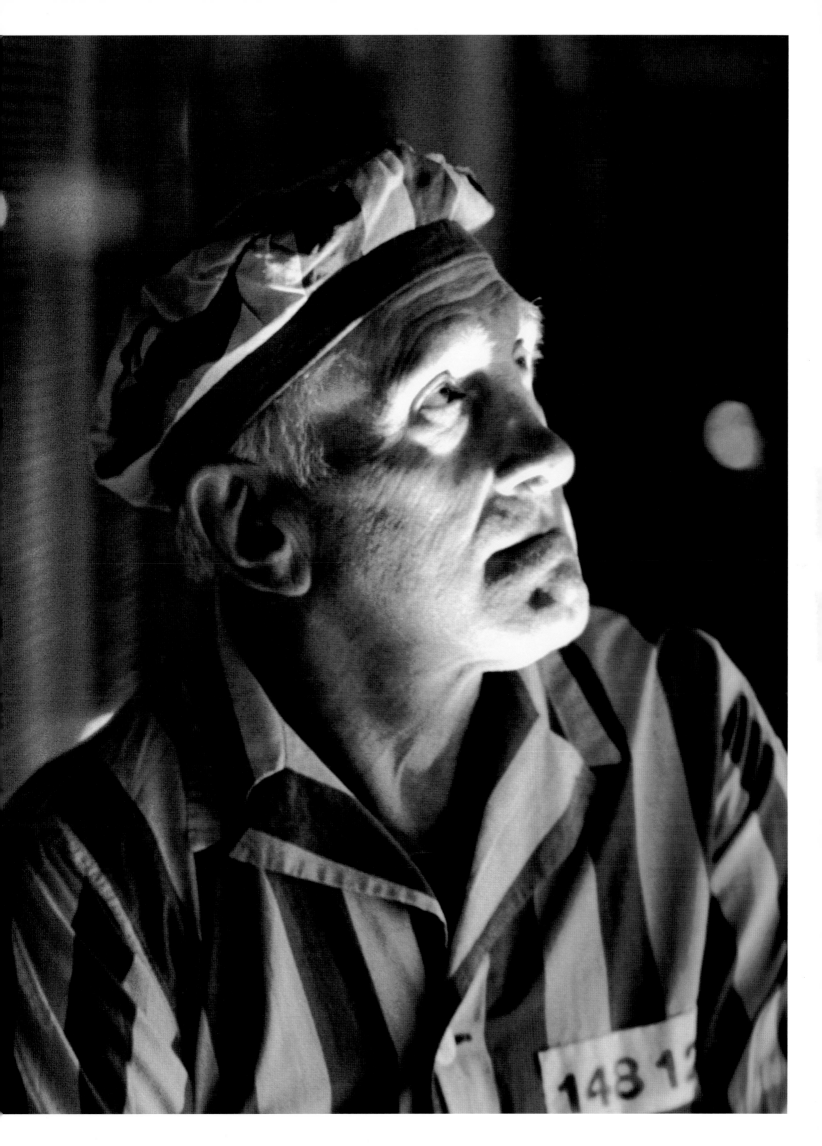

John E. Drew is president and CEO of the World Trade Center—a joint venture with Fidelity Investments—and the adjacent Seaport Hotel on the South Boston waterfront. He is the founder and president of The Drew Company, a Boston-based real estate management and development company internationally known for its innovative real estate projects. John has been at the forefront of the development of the five-building 2.75-million-square-foot complex of office space, hotel, and meeting facilities, and the planned Waterside Place, which will consist of 475,000 square feet of retail space and 210 condominiums.

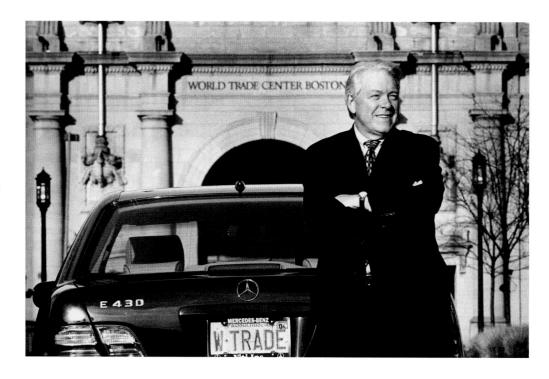

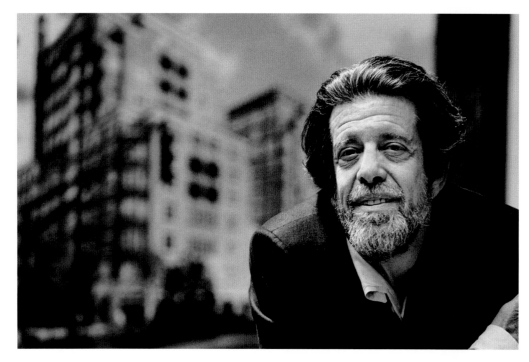

Ronald M. Druker, president of the Druker Company, Ltd., can hardly turn a corner in Boston without seeing some building or project his company or family has worked on over the years. Some of the more notable projects include Atelier 505, which mixes high-end condominiums with two black-box theaters, restaurants, and retail; The Heritage On The Garden, facing Boston's Public Garden; and the Colonnade Hotel and residences. Ron serves on numerous boards and participates in many charitable events. He is the president of the Greater Boston Real Estate Board.

Son of the legendary Boston developer Norman B. Leventhal, Alan M. Leventhal not only made a name for himself, but he's also rewriting the story of the city's skyline. Chairman and CEO of Beacon Capital Partners, Alan made history when, in 2003, his company paid $910 million for the iconic John Hancock Tower and two other buildings. The transaction was Boston's largest real estate sale. But Alan is more than his real estate deals; he serves as the chairman of the Boston University Board of Trustees and supports numerous local charities.

As chairman and CEO of Arnold Worldwide, **Ed Eskandarian** quietly leads New England's largest ad agency, and as a limited partner of the Red Sox his support for the team is just as low-key. "He is reserved, but a formidable businessman," said one of his competitors. "In a business with a lot of flash, he's all substance." Arnold recently announced an effort to develop movie and television projects and to provide Internet materials and other creative content to promote client products and brands.

Red Sox General Manager **Theo Epstein** proved he can pull off more than a deft player trade when he and his cover band, Trauser, roared through a set at the "Hot Stove, Cool Music" fundraiser at the Paradise in January 2004. Trauser joined a stellar lineup of rockers with local ties—Kay Hanley, the Gentlemen, the Loveless, and the Dropkick Murphys. The event, organized by baseball writer Peter Gammons, raised $55,000 for the Jimmy Fund on one cold winter night.

Discretion prevents **Christopher Drake** (seated) and **Lee Bierly**, premier Boston interior designers, from revealing exactly which Beacon Hill home or Nantucket summer house or Back Bay pied-à-terre they have worked on, but it's a good bet that if you've been in the best homes in the region you've seen their work. Hanging their shingle on Arlington Street (another of the city's best addresses), Lee and Christopher have been at the forefront of those bridging old-world Boston style with today's more functional needs. And their work doesn't stop at sundown: they are among the city's top fundraisers for a host of causes.

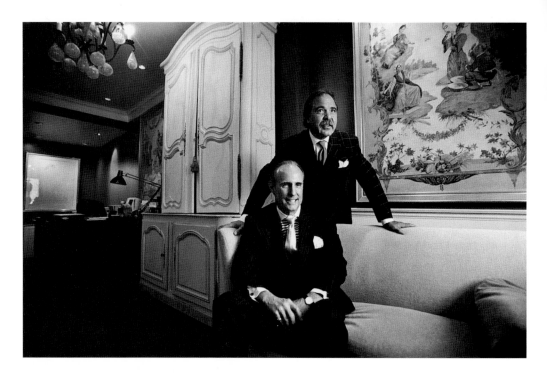

The state legislative leadership duo of Senate President **Robert E. Travaglini** of East Boston and House Speaker **Salvatore F. DiMasi** of the North End have put a flavorful focus on the rise of Boston's Italian-American politicians. Political observers—and there are more than a few in these parts—say Massachusetts citizens will notice as this pair starts to shape the public debate. In the time both have been in their leadership roles, there's been an unprecedented amount of cooperation among the State House legislators; and the two haven't really begun to hit their stride.

Academy Award–winning writer-actor **Matt Damon** seems to relish the times he returns home to the Boston area, usually to help out a charitable cause or event. Matt and his girlfriend, **Luciana Barroso**, an interior designer from Miami, share a laugh at a fundraiser at the Boston Harbor Hotel. Matt returned home for work in 2005 when director Martin Scorsese filmed scenes in Boston for *The Departed,* also featuring Leonardo DiCaprio, Mark Wahlberg, and Jack Nicholson.

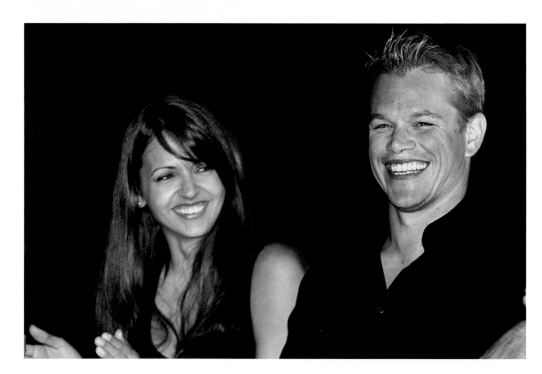

David F. D'Alessandro is the marketing whiz who rose through the ranks to become the chairman and CEO of John Hancock Financial Services Inc. and then to manage the successful merger of that company with Manulife Financial Corporation. David served as president and COO of Manulife before stepping down in late 2004. While at Hancock, he oversaw and directed a period of unprecedented expansion—growth that extended not only to corporate sponsorships, chiefly the Boston Marathon, but also to the Olympic Games worldwide and Major League Baseball.

Frank Doyle is president and CEO of Connell Limited Partnership, a manufacturer with facilities throughout the United States, Mexico, Canada, China, and East Germany. With consolidated sales exceeding $1 billion, Connell is ranked number 277 on *Forbes* magazine's list of largest private companies. Before joining Connell in 2001, Frank was vice chairman at Price Waterhouse Coopers. He is on the board of Liberty Mutual, Citizens Bank, Boston College, and Joslin Diabetes Center, and serves as an executive committee member for several Boston nonprofit organizations.

Loyalty is too often rare, but not for the Corcoran family and not when it comes to Emmanuel College. Chairman of Corcoran Jennison Companies, Joseph Corcoran, center, and his family established a scholarship in honor of Sister Catherine Theresa Corcoran, second from left, an Emmanuel graduate. The family, including Leo, left, and John, right (now deceased) were joined by more than 100 people at the reception. "Emmanuel students will be touched by the generosity of the Corcoran family and their love and respect for their sister," Emmanuel president Sister Janet Eisner, SND (second from right) said in her address.

Susan Wornick, **Hank Phillippi Ryan**, and **Paula Lyons**. The very names should strike fear in anyone trying to rip off or pull a fast one on the local TV viewing audience. During their time as investigative reporters on the consumer beat, this trio has been credited with exposing millions of dollars in fraud and potential lost money. And despite their obvious camaraderie, they have competed against each other for years. Susan, who also anchors the noon news on WCVB-TV, does regular "Buyer Beware" segments for the station. Hank works as an investigative reporter as well as anchoring her popular "Real Deal," "Hank Investigates," and "Help Me Hank" features on WHDH-TV. And Paula was a 20-year veteran of the consumer beat before leaving WBZ-TV. She is now a media consultant.

It was once said that if someone was holding a competitive game of tiddly-winks, **Doug Flutie** would not only be there but would also figure out the game and then master it. So when Doug and his wife, Laurie, learned their son was autistic, they applied the same effort to helping others facing the same challenges, establishing the Doug Flutie Jr. Foundation for Autism. This portrait of Doug Sr. and Jr. was taken just before one of the many events the Fluties use to raise money to help families with autistic children. Of course, Doug Sr. is best known for his exploits on the football field. A Boston College legend, he returns to New England in 2005 as a quarterback (the oldest in the NFL) for the New England Patriots.

Richard L. Friedman, president and CEO of Carpenter & Co., is the man behind the development and operation of the Charles Hotel in Harvard Square. And his $100 million redevelopment of the Charles Street Jail at the foot of Beacon Hill into a 308-room luxury hotel is underway. He also developed the Logan Hilton. Dick and his wife, the photographer **Nancy Klemm Friedman**, are friends of Bill and Hillary Rodham Clinton and have hosted the former first couple at the Friedman summer house on Martha's Vineyard. When the then First Lady came to town for a fundraiser for the Reach Out and Read literacy program, she wowed the crowd by reading from *Henrietta,* a children's book by playwright David Mamet about Dick Friedman's late pig—and the namesake of a Charles Hotel eatery.

Noted economist, author, and diplomat **John Kenneth Galbraith** and his wife, **Kitty**, were the toast of the night at an event in September 2003 to benefit Mount Auburn Hospital. After teaching at both UCLA and Princeton, he joined Harvard's faculty in 1948. A counselor to the Kennedys, he served as ambassador to India during the Kennedy administration. But his involvement in government had actually started years before: during World War II, he was in charge of wartime price controls.

A chance to catch the J. Geils Band perform live is something any true fan of bluesy, grinding, R&B-influenced rock and roll should not miss. Those attending a $2,500-a-head fundraiser at the Charles Hotel in early 2005 to benefit the charitable foundations of hockey great Cam Neely, actor Michael J. Fox, and comic actor Denis Leary, got that rare opportunity. Guitarist **Jay Geils** and the indefatigable singer/piano player **Peter Wolf** were joined by their bandmates for a late-night concert. Their biggest hits included "Freeze Frame," "Centerfold," "Looking for a Love," "Give It to Me," and "Must of Got Lost." Although all members are still active, the band broke up in 1985.

Lawrence K. Fish is chairman, president, and CEO of Citizens Financial Group, Inc. A banker's banker, he led Citizens through an extraordinary period of growth, making it one of the 20 largest commercial banks in the country. *Boston Globe* columnist Steve Bailey wrote of Larry's tenure at Citizens: "At a time when Fleet and Hancock and Gillette have all fallen like dominoes, when old New England nameplates like Filene's are headed for extinction, Citizens is a runaway New England success story." Larry is an overseer of the Boston Symphony Orchestra and is on the board of the Dimock Community Foundation. He has helped lead major initiatives and capital campaigns for nonprofit organizations, including Rosie's Place and the Vietnamese Community Center.

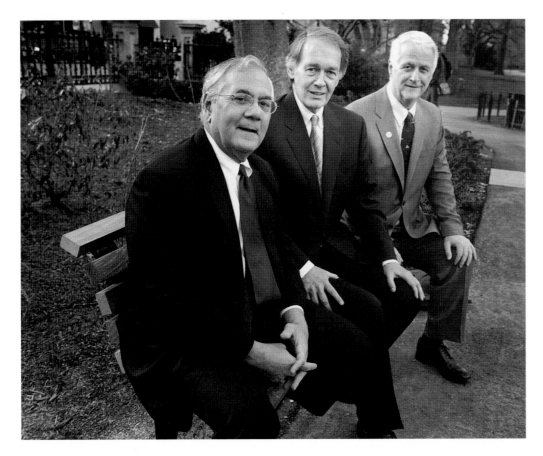

These three U.S. congressmen, **Barney Frank**, **Edward J. Markey**, and **William Delahunt**, share more than a common mission—representing the interests of a sizable portion of the residents of eastern Massachusetts. Barney, Ed (the dean of the Massachusetts congressional delegation), and Bill were sworn in as representatives in the Massachusetts Legislature on the same day in 1972.

As President, Northeast, for Bank of America during its merger with FleetBoston Financial, **Anne M. Finucane** had the job of developing and executing strategic plans for New England, New York, New Jersey, and Pennsylvania. Anne has since taken on the added responsibility of overseeing public policy and the charitable foundation company wide. It is a role she prepared for as chief marketing officer at FleetBoston Financial, which she joined in 1995. Before joining Fleet, she operated her own consulting firm and served in a variety of senior management positions at Hill Holliday, the region's largest advertising agency.

John R. Silber, president emeritus of Boston University and professor of philosophy and law, takes a moment to look out from his new offices on Bay State Road. During his 25-year presidency, he was credited with building the school into an academic center with an international reputation. This portrait was taken in early 2005 just a few weeks before his wife, Kathryn Underwood Silber, the beloved "first lady" of Boston University, died after a long illness. Outspoken and often controversial, John Silber continues to be an integral member of Boston's academic community.

From Bank of Boston Corporation and its principal subsidiary, The First National Bank of Boston, to Bank-Boston to Fleet Financial Group, and ultimately to Bank of America, one name has remained the same: **Chad Gifford**. Although he retired in early 2005, Chad has maintained his connections to the Boston community. He served as chairman of the Boston Plan for Excellence in the Public Schools and was the founding chairman of the United Way of Massachusetts Bay's "Success By 6" initiative. Other nonprofit organizations Chad has worked with over the years include Northeastern University, the Boston Symphony Orchestra, Carnegie Hall, WGBH Public Broadcasting, Junior Achievement, the Dana-Farber Cancer Institute, the Greater Boston Chamber of Commerce, and the Greater Boston Food Bank.

Through the ups and downs of the economy, changes in the real estate market, and pressure from international competition, **John Fish**, president and CEO of Suffolk Construction Company, has been at the forefront of Boston's transformation into a world-class city. John has run the company since taking it over from his father in 1982. Hardly a street in Boston hasn't seen a Suffolk Construction project. Some recent notable projects include the renovation and new addition at the Four Seasons Hotel, Wilkes Passage in the South End, Nine Zero Hotel on Tremont Street, and the Mandarin Oriental Hotel & Residences.

Seated in front of helmets from National Football League franchises, Reebok CEO **Paul Fireman** seems like the kind of guy who lives and breathes sports. But that's just not Paul. He's the marketing and business genius who launched the first women's athletic footwear in 1982, an aerobics shoe that spurred a fitness and fashion revolution. Inspired by people he met, Paul launched the Reebok Human Rights Awards (and has contracted for human-rights audits of his factories). You cannot talk about Paul Fireman without mentioning his wife, Phyllis. Whether through the foundation that bears their name, or HomeFunders, which builds housing for low-income families, or One Family Inc., which seeks lasting solutions to family homelessness, the Fireman family supports the city's residents through actions big and small.

Real estate developer **Thomas J. Flatley** stands at the $1 million Irish Famine Memorial, which was unveiled in 1998 to commemorate the 150th anniversary of the height of the "Great Hunger." Tom is chairman of the committee that created the park, located at Washington and School streets on the Freedom Trail downtown. The site features twin sculptures by artist Robert Shure and eight narrative plaques that chronicle the "odyssey of the Irish from tragedy to triumph." At the unveiling, Tom said: "This is a remarkable day for the people of Boston, who have joined together to honor not just the Irish but all immigrants who struggle to succeed in America." Tom's work isn't finished. The Boston Irish Famine Memorial Committee has established an Irish Famine Institute to help those suffering from hunger and famine today.

Leonard Florence is leaning on his trademark Rolls Royce, but his story starts when he was seven years old, one of nine children born to Russian immigrants, who grew up in Chelsea shining shoes and wearing his brothers' hand-me-downs. Chairman and retired CEO of Syratech Corporation, Lenny has had a remarkable run in the silver and home decor businesses, starting with his own company, Leonard Silver, which merged with Towle, one of the oldest companies in the United States; acquiring Farberware; and finally forming Syratech. Lenny was once aptly described as an "interdenominational philanthropist."

From rare and precious items to large tracts of land to government property, Boston auctioneers **Dan Flynn**, **Ed Smith**, and **Paul Saperstein** have sold tens of millions of dollars' worth of property. Each with his own firm, the three together have nearly 100 years of experience. Each has another credit to his name: the donation of services to raise millions for charities in the Boston area.

It's on West Street right in downtown, and if you are a bibliophile you have made a pilgrimage there: Brattle Book Shop, founded in 1825. **Ken Gloss** follows in his father George's footsteps, running a three-story shop with more than 250,000 books, maps, prints, and other items. Internet shopping has changed the book business, but Ken still runs an amazing brick-and-mortar enterprise where book lovers, scholars, and plain old-fashioned readers can peruse the shelves and pick out the books they want. As well as selling books, from rare first editions to general-interest titles, Ken appraises books and libraries for families and institutions.

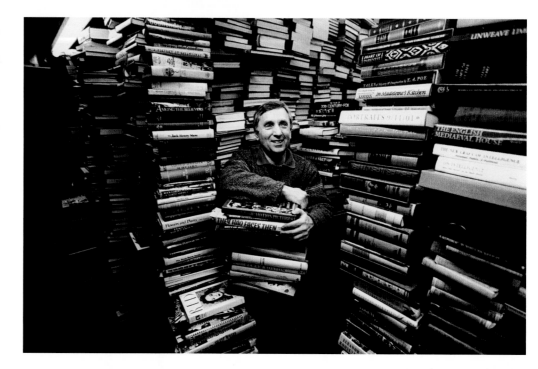

Thousands have been inspired by these three men, who carry many titles, including teacher, speaker, author, scholar, and leader. **Henry Louis "Skip" Gates Jr.** is director of the W. E. B. Du Bois Institute for African and African American Research and chair of the Department of African and African American Studies at Harvard. **The Reverend Peter Gomes** is the Pusey Minister and Plummer Professor of Christian Morals at Harvard. **Charles Ogletree** is Harvard Law School's Jesse Climenko Professor of Law, and founding and executive director of the Charles Hamilton Houston Institute for Race and Justice.

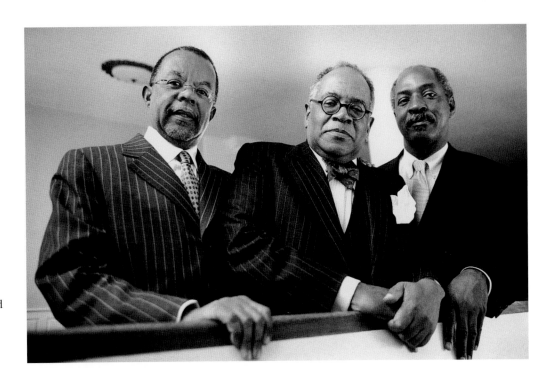

Chris Gabrieli is a successful businessman, active Beacon Hill resident, and leading advocate for after-school programming for children. But it is as a political candidate that most people know him. It's one title he doesn't readily attach to himself. "Yes, I've run for office," Chris said, "but I see myself as part of a larger trend, where entrepreneurs with business sense have applied it to a more civic purpose." His portrait was taken on Beacon Hill, where Chris now heads Massachusetts 2020, a nonprofit foundation aimed at expanding educational and economic opportunities for children and families across the state.

Seen here at the Somerville headquarters of his company, Mass Envelope Plus, one might get the impression that **Steve Grossman** is out of politics. Not true. The former chairman of the state and Democratic National Committee is still one of the most effective political operatives around. Steve's always had a unique take on how politics should run (and a notorious sweet tooth). When he dropped out of the race for governor in 2002, he gave each of his 15 staffers a month's severance pay and took them out for raspberry-lime rickeys, Junior Mints, Almond Joys, and Reese's Peanut Butter Cups.

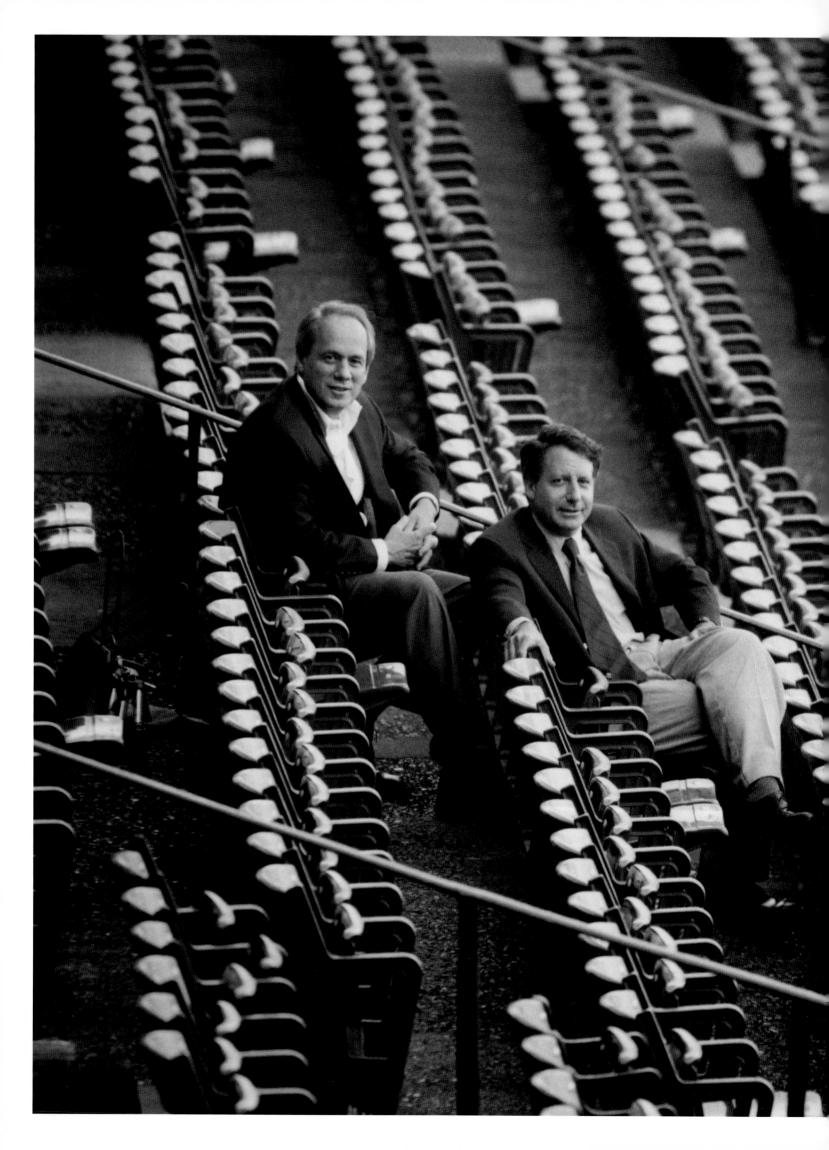

At the time this portrait was taken, in the summer of 2004, the management team of Boston's Major League Baseball franchise could only be hopeful about the outcome of the season. But president and CEO **Larry Lucchino**, chairman **Tom Werner**, and principal owner **John W. Henry** led the way—and the team, its fans, the city, and the whole region followed along. By late October, the Red Sox were the World Champions for the first time since 1918. Since this ownership team has taken over, historic Fenway Park has seen numerous fan-friendly improvements (expanded and modernized bathrooms) and modifications (seats on the Green Monster and the right-field roof). The new owners started the Red Sox Foundation in 2002, which has already raised $7.5 million for Red Sox charities, with another million expected to be raised by the end of the 2005 season. And the fans continue to flock. As of April 2005, when the Fenway gates opened to begin the season, the Red Sox had sold out 125 consecutive home games.

The Boston Foundation is one of the nation's oldest and largest community foundations, with an endowment of more than $630 million. As its president and CEO since 2001, **Paul S. Grogan** oversees one of the most important organizations in the city. Foundation-supported programs cover a broad range of needs, from the arts to housing to education to workforce development. Prior to joining the foundation, Paul was vice president for government, community and public affairs at Harvard, and president and CEO of the Local Initiatives Support Corporation, the largest community development intermediary.

Steve Grogan played in 149 games during his 16 years in the National Football League (1975–1990), all of them in a New England Patriots uniform. Some say quarterbacks aren't tough, but the team's official guide still counts Steve as being "one of the hardest hitters and toughest players in Patriots history." He remains the team's all-time career passing leader with 3,593 attempts, 1,879 completions, 26,886 yards, and 182 touchdowns. He rushed for 2,164 yards (a 4.9 average) and 35 touchdowns during his career. His 12 rushing touchdowns in 1976 remain the season high for a quarterback in all of NFL history.

John P. Hamill served as chairman and CEO of Sovereign Bank New England for five years before stepping down in early 2005. He remains closely involved with the bank, helping both to attract new business and to develop new talent. And John continues to be active in the community, helping Sovereign to continue its role as a solid corporate citizen, while he works with all the community boards with which Sovereign is affiliated in New England. Before going to Sovereign, John was president of Fleet National Bank, Massachusetts, and before that he was president of Shawmut Bank for 12 years.

Both are ministers and physicians. **Rev. Dr. Gloria E. White-Hammond** is a co-pastor of the Bethel African Methodist Episcopal Church in Jamaica Plain and has been a pediatrician at the South End Community Health Center since 1981. Additionally, Gloria was part of a coalition of black ministers who traveled to Sudan in 2001 with a mission led by Christian Solidarity International to liberate slaves. She returned a year later to give medical care to slaves disfigured by abusive owners. Early in 2005, Gloria traveled with a group to the Darfur region of Sudan to witness the devastation that the U.N. had already condemned as a holocaust. Gloria's husband, **Rev. Dr. Raymond Hammond**, a former emergency room doctor, is senior (and founding) pastor of the Bethel AME Church. Ray also is a founder and president of the Ten Point Coalition, an ecumenical group of clergy and lay leaders working to mobilize the community around issues affecting black and Latino youth.

Paul Guzzi came to his position as president and CEO of the Greater Boston Chamber of Commerce with a résumé packed with public and private experience. He is a former Massachusetts secretary of state and chief secretary to the governor. He has served as a vice president of state and community affairs for Boston College; as a consultant for Heidrick & Struggles, an international recruitment and consulting firm; and as vice president at Data General Corporation. During his tenure at Wang Laboratories, he worked closely with Dr. An Wang to oversee the restoration and transformation of what is now the Wang Center for the Performing Arts, an organization he continues to support.

Alpha Omega's founder **Raman Handa** is flanked by his children, vice president of communications **Nidhi** and vice president of fine watch sales **Amit**. Both Alpha Omega and the Handas have become premier authorities on watches and timepieces. As business at their four locations has flourished, the family has become increasingly involved in area charities and social events.

She's a little bit Town & Country and her daughter's a whole lotta rock 'n roll. When **Julie Hatfield** covered the world of haute couture for the *Boston Globe,* designers made it a point to check out "who" Julie was wearing. Later, when she covered the social scene with the popular "Party Lines" column, an event wasn't considered a success if they didn't have Julie and Bill Brett in attendance. Daughter **Juliana** first burst onto the local pop scene with the trio the Blake Babies, which she disbanded in 1990 to pursue a solo career. Her song "Hey Babe" was a hit in 1992, and she has been building on her success ever since. A Boston performance by Juliana is one of the toughest tickets in town.

Perhaps best known as the former CEO of the Boston Red Sox, Boston native **John L. Harrington** orchestrated the 2002 sale of the team for $700 million, a price more than double that of any other baseball team in history. Never a fan of the limelight during his tenure with the Red Sox, he preferred the company of his wife, Maureen, another native Bostonian, and their grandchildren during home games. Today he is a quiet force in philanthropy as a trustee and executive director of both the Thomas A. Yawkey Foundation and the Jean R. Yawkey Foundation, which donate to many causes, including the Pine Street Inn, Rosie's Place, the Greater Boston Food Bank, Tom Yawkey Wildlife Center, the Jimmy Fund, Tara Hall Home for Boys, the Baseball Hall of Fame, Massachusetts General Hospital, and many others.

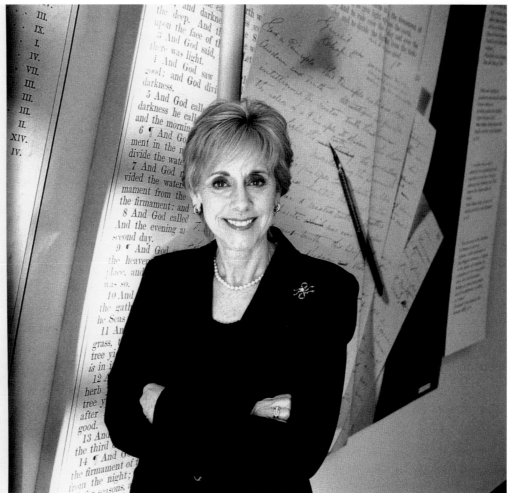

Virginia Harris is chairman of the Christian Science Board of Directors, making her the leader of the organization whose worldwide activities include publishing Mary Baker Eddy's perennial bestseller, *Science and Health with Key to the Scriptures,* and the seven-time Pulitzer Prize–winning newspaper, the *Christian Science Monitor.* A sought-after commentator, Ginny has appeared on numerous television and radio shows to discuss society's growing search for spirituality and its meaning.

Kenneth I. Guscott is not the flashiest developer in town, nor does he seek the headlines. For decades he has quietly ensured that those who traditionally had been cut out of the biggest projects have been able to play a role in the development of downtown and also be well represented. That's something he has passed on to his daughter, **Lisa**. Kenneth's Long Bay Management Company was out front in representing the Columbia Plaza Associates, the original development team of what is now One Lincoln Street. Kenneth was on hand recently when the Urban League honored Columbia Plaza Associates at its annual awards gala. But his involvement in the community doesn't stop there. As the honorary consul to Jamaica, he raised money to help those who were devasted by Hurricane Ivan in 2004.

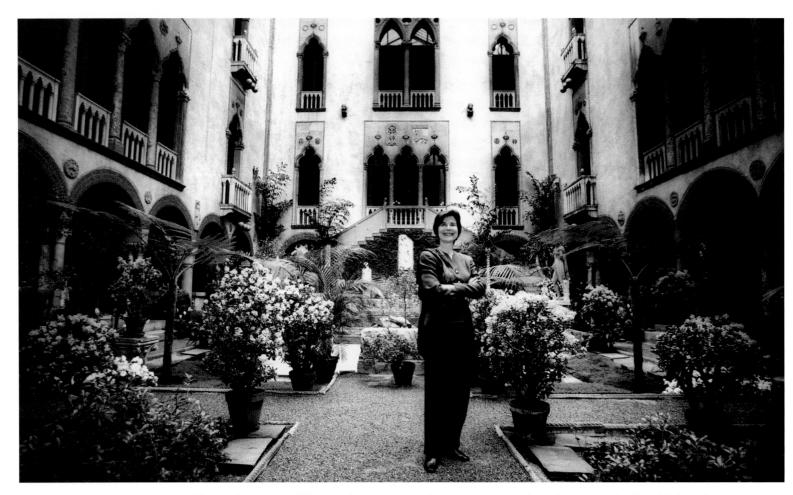

Anne Hawley, the Norma Jean Calderwood Director of the Isabella Stewart Gardner Museum, stands in the Fenway landmark's famed courtyard. Of the 1903 creation of her museum, Mrs. Gardner said, "Years ago I decided that the greatest need in our Country was Art." That is a legacy Anne has upheld in her 15 years as director, overseeing a 1992 effort to reach out to the artistic community to seek its input in the renovation of the museum, and in the establishment of an artist-in-residence program.

Since becoming president of the Massachusetts AFL-CIO in 1998, **Robert J. Haynes** is credited with expanding the role unions play in a changing political and business environment. Among the achievements Bob counts as his most important: defeating ballot questions on the prevailing wage law and state tax cuts; increasing the state minimum wage twice, making it the highest in the nation; and repeatedly electing pro–working family candidates like Senator Edward M. Kennedy, whom Bob calls "the most forceful voice for organized labor on Capitol Hill."

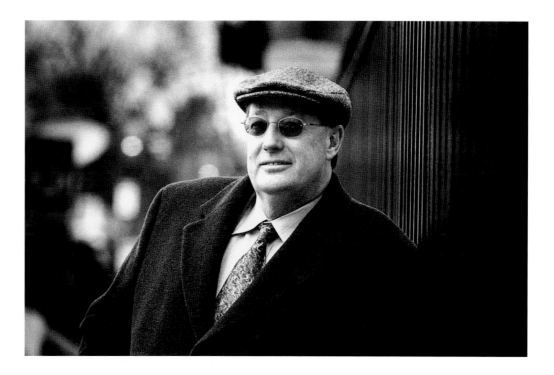

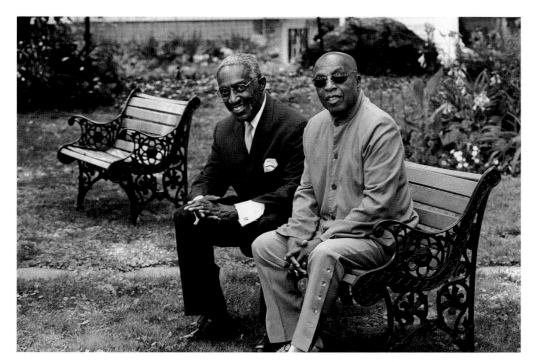

The Rev. **Michael Haynes**, long-time minister at Twelfth Baptist Church in Boston, is a leader in his community and an inspiration in the pulpit. He was also a friend of the slain civil rights leader Martin Luther King Jr. Here Michael sits with the man he recently described as "my oldest living brother, **Roy Owen Haynes**." A renowned jazz drummer, Roy has "performed with just about everyone," according to one biographer. But it's worth listing a few names. A member of the Charlie Parker quintet, Roy has recorded with Stan Getz; toured with Sarah Vaughn, Chick Corea, and Pat Metheny; and gigged with Miles Davis and Dizzy Gillespie.

State Representative **Kevin G. Honan** and activist **Susan Tracy** stand in front of the Honan-Allston Branch of the Boston Public Library, named for Kevin's late brother, Brian J. Honan. A city councilor and candidate for Suffolk County District Attorney, Brian died unexpectedly at age 39 in 2002. His impact was so great that there are already an apartment building and neighborhood park named for him, his high school has retired his basketball jersey, and a scholarship has been established in his name at Harvard University.

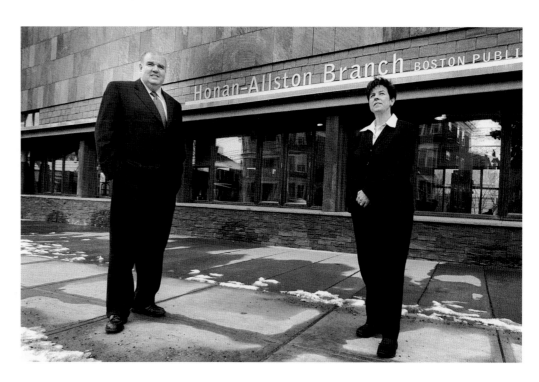

For Back Bay resident **Jane M. Holt**, suffering from pancreatitis was not where she was going to leave her story. She joined Pittsburgh resident Patricia S. Birsic to form the National Pancreas Foundation. With an almost unprecedented goal of channelling 95 percent of money raised to research and humanitarian aid, the two women have helped fill a vacuum in funding, patient information, and awareness of pancreas-related illnesses.

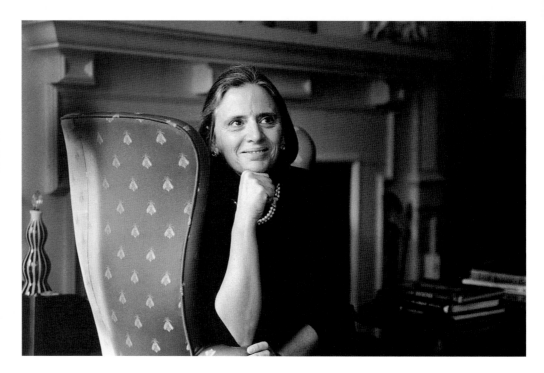

When **Marian L. Heard** retired from her post as president and CEO of United Way of Massachusetts Bay, her send-off gala drew more than 800 guests—the kind of crowd Boston usually sees for a cause, not an individual. In Marian's 15 years at the helm, the United Way of Massachusetts Bay launched Success by 6, which aims to insure all children enter school healthy and ready to learn; created (with the Boston Foundation) the $30 million United Way Millennium Fund for Children and Families; and created Today's Girls . . . Tomorrow's Leaders, a program for young women.

Arnold Hiatt never attended business school, but he could teach volumes. As chairman of the Stride Rite Foundation, Arnold has applied the ideals he set in motion during 24 years at the Stride Rite Corporation. The Cambridge-based shoemaker, most famous for the Keds and Sperry brands, was highly profitable but also socially responsible. "We would do well to become more responsible for our communities and our employees, and thereby serve our stockholders even better than we have in the past," Arnold told a reporter. Philanthropy runs in the Hiatt family; Arnold is the brother of Myra H. Kraft.

Thomas J. Hynes Jr. knows just about everything one man could about the Boston real estate market. As president since 1988 of Meredith & Grew, a firm he joined in 1965, Tom has 40 years of experience in the sale and leasing of, and consulting on, commercial, industrial and institutional real estate. He is chair of the Massachusetts Business Roundtable, a trustee of Prentiss Properties, and past chair of ONCOR International. Tom also serves on the board of advisers for Boston College's Carroll School of Management.

Veteran TV broadcaster **Jack Hynes**, who still makes regular appearances on the WB affiliate Channel 56, and his son, **John B. Hynes III**, CEO of Gale Co., the man behind the biggest lease in Boston history, have a long and storied family tradition in Boston. Jack's father, John B. Hynes, was mayor of Boston from 1950 to 1959. The younger Hynes, who now spends much of his time in South Korea, where his company is overseeing a $25 billion building project for the government, loves to point out that his grandfather beat the legendary and popular Boston mayor James Michael Curley three times in runs for mayor.

These four men have had Boston covered. **John Henning** was the dean of television political reporters, holding court at WBZ-TV and other stations over many decades. He is now a senior adviser with Denterlein Worldwide Public Affairs. **Ed Fouhy** is a retired network television news executive and a contributing editor to *Media Nation*. The late *Boston Globe* columnist and reporter **David Nyhan** continued to write columns for four daily newspapers until his death in early 2005. And **Dick Flavin**, one of the country's leading humorists, won seven Emmy Awards for local television commentary.

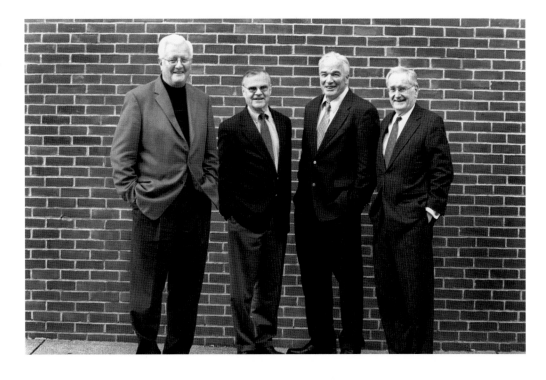

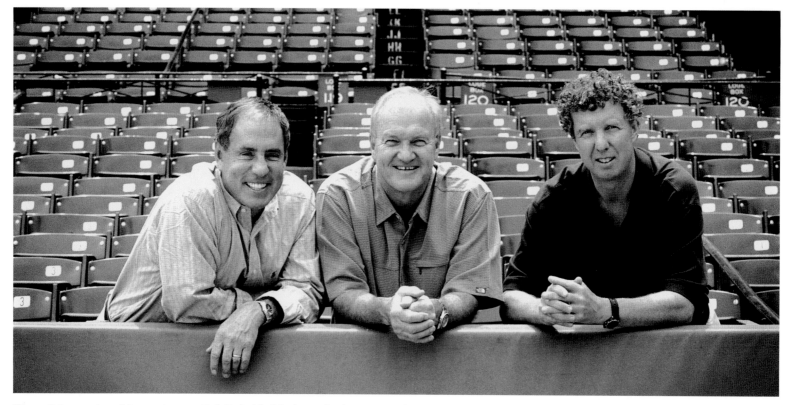

They all have other things going on. **Bob Lobel** holds down the fort as CBS4's sports anchor. **Mike Barnicle** is a newspaper columnist and regular commentator on both cable and network news shows. And **Dan Shaughnessy** is a sports columnist for the *Boston Globe* and the book author who coined the phrase "the curse of the Bambino" to explain why the Red Sox had an 86-year championship drought. But you get the sense that it's when these three are together for a couple of hours in the middle of the day on Barnicle's show on FM talk station WTKK that they are most happy. Said Barnicle: "We enjoy ourselves and hopefully other people enjoy it and maybe learn something from it, too."

Whether they were anchoring the nightly newscasts or raising millions of dollars for charities, particularly the Muscular Dystrophy Association, **Natalie Jacobson** and **Chet Curtis** didn't just report headlines; as one of the more recognizable couples in the Boston area, they sometimes made the headlines as well. And now that they have split both on screen—Natalie stayed with WCVB and Chet moved to New England Cable News—and off, some point to their break as the end of the celebrity news anchor era in Boston.

It was a happy night for **Edward C. "Ned" Johnson III** and his wife, **Elizabeth**, as he accepted the public service award at the Boston Bar Foundation's John and Abigail Adams Benefit Ball in the fall of 2003. Not known for seeking the spotlight, Johnson was honored for years of service and civic and charitable support. As chairman and CEO of the mutual fund powerhouse Fidelity Investments, Ned runs the company his father founded in 1946. And the tradition continues with the Johnsons' daughter, Abigail, who is president of Fidelity Employer Services Company.

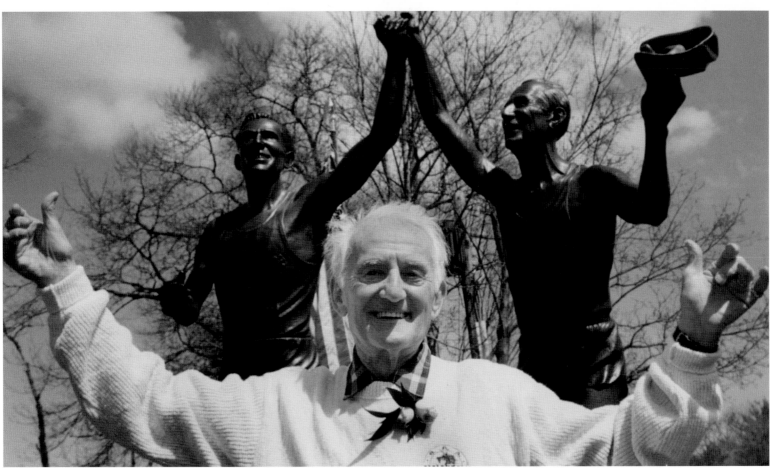

Heartbreak Hill has earned its name by dashing the hopes of thousands of runners in the 109 years of the Boston Marathon. **Johnny Kelley** earned his statue—titled *Young at Heart*—on that treacherous stretch of Commonwealth Avenue by running the Boston Marathon a record 61 times (completing 58, another record). Johnny won the race twice, came in second a record seven times, and in 18 of the trips from Hopkinton to the Back Bay, he finished in the top 10. A three-time Olympian (1936, 1940, 1948), Johnny ran his last Boston Marathon at age 84 in 1992, finishing in under six hours. When he died at age 97 in the fall of 2004, four-time Boston winner Bill Rodgers said, "He *was* the Boston Marathon."

Tripp Jones works behind the scenes for those who might not otherwise be heard. He is senior vice president and chief administrative officer of the MENTOR Network, a national provider of residential and support services for people with developmental and other disabilities. He is co-founder and former executive director of MassINC, the Massachusetts Institute for a New Commonwealth, which is committed to promoting the growth and vitality of the middle class through quality research, journalism (such as the publication of *Commonwealth* magazine) and public education programs.

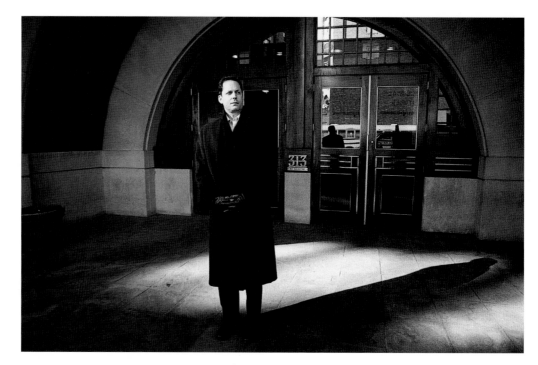

Richard M. Kelleher is chairman and CEO of the Boston-based Pyramid Hotel Group, which owns and manages 15 hotel properties in the United States and has acquired and developed nearly $500 million worth of hotels in the past three years. Rick is the former president and COO of the Promus Hotel Corporation and former president and CEO of Doubletree Hotels Corporation. As founder of Beacon Hospitality Group, a national hotel development and management company, Kelleher took his company from zero to 40 hotels in four years. Most recently, he has built executive teams in Boston, Phoenix, and Memphis.

After shunning the spotlight for years, **Jeremy Jacobs** has become much more visible in a city where he owns the premier indoor sports and entertainment venue and the local NHL franchise, the Boston Bruins. The chairman and CEO of Buffalo-based Delaware North Companies, Jeremy named his son, **Charlie**, a Boston College graduate, executive vice president of both Delaware North and the Boston Bruins in 2002. A flurry of activity ensued in 2004 and 2005, as the then FleetCenter hosted the Democratic National Convention, the NHL cancelled an entire season, and the venue changed its name to the TD Banknorth Garden.

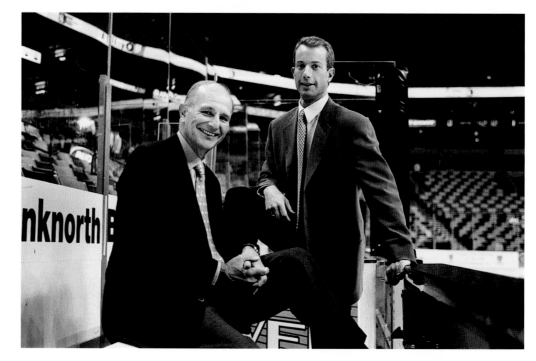

It's been said that few in Boston have used the civic platform to greater effect than **Hubie Jones**. A professor and dean emeritus of the Boston University School of Social Work, he was a director of the Community Fellows Program at the Massachusetts Institute of Technology and stepped in as acting president of Roxbury Community College during its reorganization. Known for his personal style of advocacy, Hubie has also made his mark in business, community groups, and government. While at a convention in Chicago he heard the renowned Chicago Children's Choir. Hubie was so moved by the performance that he founded the Boston Children's Chorus.

Jake Kennedy and his wife, **Sparky**, ask for help only once a year and for only one cause: Christmas in the City. One Sunday every December, the Kennedys send nearly 100 buses to shelters throughout the region to transport mothers and their children to a local convention hall for a holiday celebration. "For those six hours, we were human beings," one former attendee told the *Boston Globe*. "We weren't a sore on society, the rejects. People were compassionate to us, not because they had to be, but because they wanted to be."

The Irvines have formal names—**Cassandra H. Irvine** and **Horace H. Irvine II**—but most simply say "Cassandra and Hod" when referring to one of the city's most philanthropic couples. Hod is totally committed to supporting the arts in Boston, especially the Boston Lyric Opera, the American Repertory Theatre, the New England Conservatory, the Boston Landmark Orchestra, and, through Cassandra, the Huntington Theatre Company. Cassandra's causes include the Vincent Hospital at Massachusetts General Hospital, which provides medical care to all women regardless of financial need.

The **Dropkick Murphys**—and their remake of "Tessie," a 1903 song—became a symbol of the serendipitous luck that followed the Boston Red Sox to their first World Series championship in 86 years. "I think we're the good luck charm," singer and guitarist **Ken Casey**, right, half-jokingly told a *Boston Globe* reporter in the summer of 2004. Turns out it was true and the song is featured in the feature film *Fever Pitch.* The Dropkick Murphys formed in 1996 in the basement of a friend's barbershop as a "bunch of friends looking to make music." Now the egalitarian group—which also includes **Matt Kelly, Scruffy Wallace, Al Barr, Marc Orrell, Tim Brennan**, and **James Lynch**—has a string of successes. As for "Tessie," Ken said, "If it brings [the Sox] luck, then that's icing on the cake."

Debi Greenberg represents the fourth generation of her family to run Louis Boston, but she doesn't fit the fashionista category. Debi moves easily from Boston, where she's often seen dressed casually walking her dog down Newbury Street, to New York, Paris, or Milan. She eschews the flashy fashion shows, opting to meet directly with designers—particularly new or up-and-coming talent—in showrooms, stores, and factories. Here Debi perches on the steps of the trademark Louis Boston building in the Back Bay, once the New England Museum of Natural History and later Bonwit Teller.

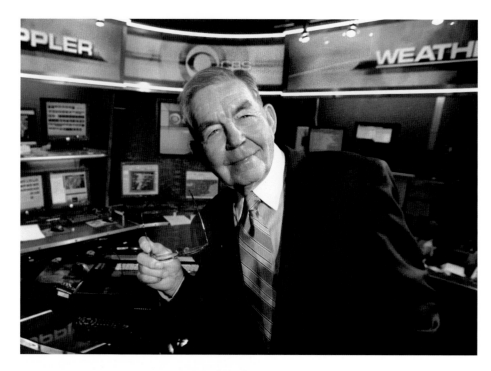

Legendary WBZ-TV weatherman **Don Kent** is not on the air anymore, but he's still one of the most familiar faces and voices in New England. Don became the staff meteorologist for WBZ's radio station and fledgling TV station in 1951, and a whole generation marked time and the weather by his broadcasts. Active in numerous charitable causes, Don is a much-sought-after speaker and celebrity spokesman.

"**Larry Kessler** embodies the belief that human will, intelligence, and heart are bigger than AIDS," James Carroll wrote in the *Boston Globe*. The founding director of the AIDS Action Committee of Massachusetts, Larry built an agency that has served more than half of all people ever diagnosed with AIDS in the state. He was running a successful business in 1982 when he first heard of a mysterious illness striking gay men. After he and others met at the Fenway Community Health Clinic to discuss the crisis, the AIDS Action Committee of Massachusetts was born.

Edmund "Ted" Kelly was born in County Armagh, Northern Ireland, but as chairman, president, and CEO of Liberty Mutual Group, he's one of Boston's leading citizens. Ted came to Boston to earn his doctorate in mathematics from the Massachusetts Institute of Technology. He was a professor before he started working in the insurance business. Since 1992, Ted has helped build Liberty Mutual from a U.S.-focused workers compensation company into one of the largest, most successful "multi-line" insurance firms in the world. It is the only Fortune 150 company based in Boston.

Paul La Camera is the president and general manager of WCVB-TV, the local ABC affiliate, where he has worked since 1972. He's been with Channel 5 since it first went on the air and has been part of the station's transformation into a nationally recognized, award-winning news and entertainment outlet. Paul's affinity for, and knowledge of, the business comes naturally. His late father, Anthony La Camera, was considered the dean of American television critics, writing for the *Boston Record American* and the *Sunday Advertiser* (where Paul worked as a reporter) and their later incarnation, the *Boston Herald American*.

Thomas G. Kelley is a Boston boy through and through. Born and raised in the city, he graduated from Boston College High. He's also a Navy man through and through. And for his "conspicuous gallantry and intrepidity at the risk of his life above and beyond the call of duty" while serving in Vietnam in 1969, Tom received the Medal of Honor. He also was awarded the Purple Heart. He retired from the Navy in 1990, and in 1999 he was sworn in as a commissioner of the state Department of Veterans' Services. He became secretary of that department in 2003.

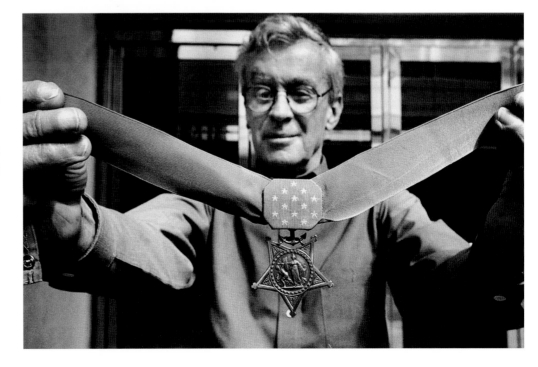

After three Super Bowl championships, it's easy to think that **Robert K.** and **Myra H. Kraft** and their four sons, **David**, **Josh**, **Dan**, and **Jonathan**, *are* the New England Patriots, the NFL franchise they acquired in 1994, and Gillette Stadium, which they built without public money. But the family has been involved in civic and charitable endeavors for decades. Bob is chairman of the New England Patriots and founder and chairman of the Kraft Group of Companies, a holding company with interests in paper and packaging, sports and entertainment, and venture investing. Myra is president and director of the New England Patriots Charitable Foundation and a trustee of the foundation that bears her and her husband's name. The Krafts have been strong supporters of the Boys & Girls Clubs of Boston and the United Way of Massachusetts. The family hosted a trip to Israel with Combined Jewish Philanthropies in early 2005 that included the rededication of the Kraft Stadium for American Football in Jerusalem.

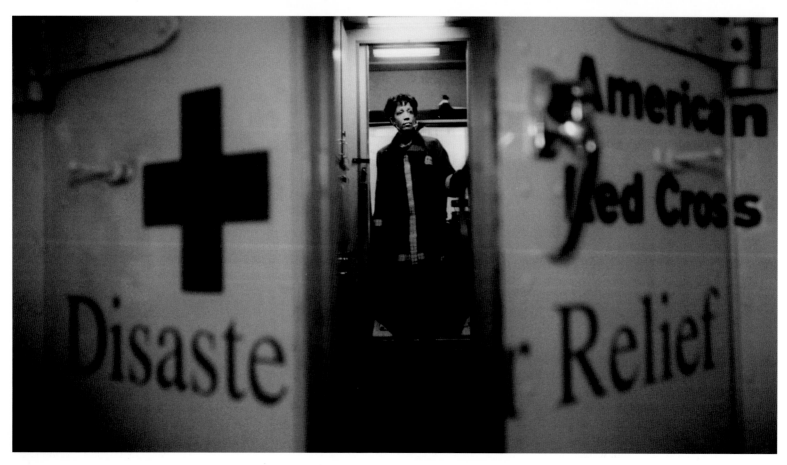

Since **Deborah C. Jackson** became CEO of the American Red Cross of Massachusetts Bay in 2002, she has met the challenge of providing direct relief to both health care providers and individuals in the aftermath of the 2001 terrorist attacks. When asked what Deborah, a civic leader for 20 years, does in her non–Red Cross time, friends answered, "What non–Red Cross time?"

The lawyers at Friedman & Atherton are known for their savvy as business and litigation attorneys. The firm also carries another distinction: it's home to the Kozols, **Joel Kozol** (center) and his two sons, **David** and **Matthew**, all partners at the firm. Joel's brother Lee H. Kozol practices with Friedman & Atherton, as did their father, the late Frank Kozol, who was the firm's senior partner, and their brother, the late Robert. "At one point there were eight Kozols here," said Joel.

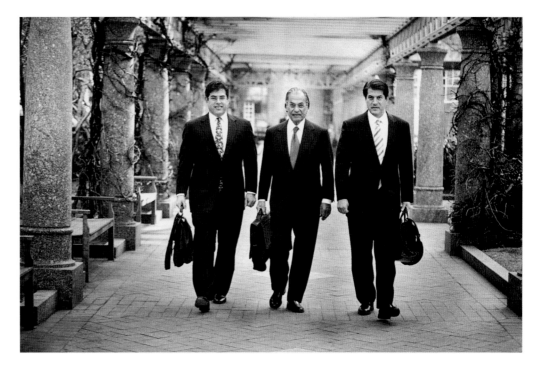

For a father to follow a son as a member of a fire department is a long tradition, but it's rare for three sons to follow their father as firefighters in the same department. **Jack Kelly**, far right, and his sons, **Sean**, **Greg**, and **Ed**, are all members of the Boston Fire Department. This photograph was taken in South Boston, where the family hails from, at the St. Patrick's Day parade in 2002—the first celebration most firefighters took part in after the events of September 11, 2001.

Hood products are familiar in many New England homes, but for **John A. Kaneb**, CEO, chairman, and president of HP Hood LLC, they're very much a family affair. The Chelsea-based company, founded in 1846 by Harvey P. Hood as a one-man delivery company, is now a $2.3 billion business with 25 plants in a dozen states. A limited partner in the Red Sox organization, John, whose family has run Hood since 1995, extends his civic and charitable reach across the city.

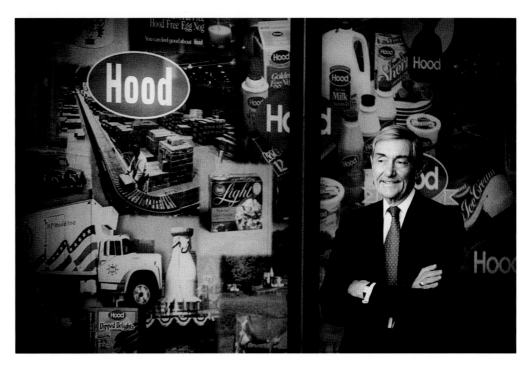

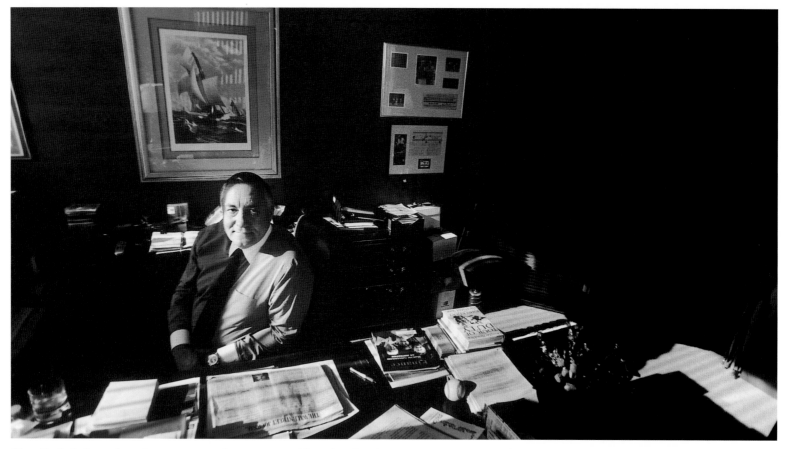

"I really do believe that what goes around comes around," said **Richard J. DeAgazio**, president of Boston Capital Securities, Inc. With multifamily housing and commercial holdings in 48 states, Puerto Rico, and the U.S. Virgin Islands, Boston Capital is one of the nation's leading real estate financing and investment firms. A regular on the local charity circuit, Richard has put his time and resources primarily behind causes that benefit young people and those that help mothers struggling to find housing or get back on their feet. A trustee at Bunker Hill Community College, Richard is active with Junior Achievement and the Ron Burton Training Village.

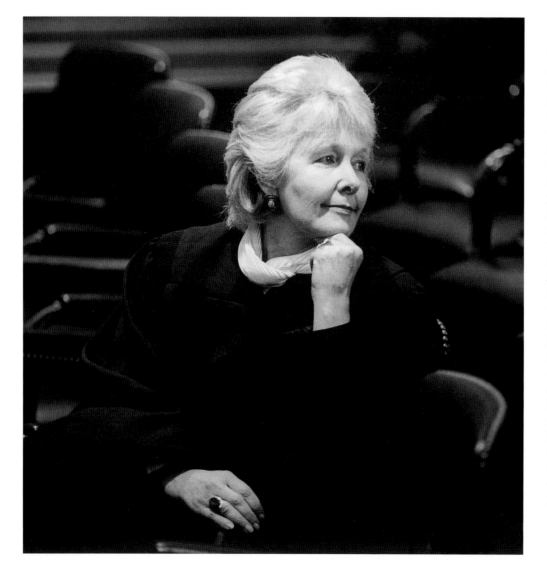

State Supreme Judicial Court Chief Justice **Margaret H. Marshall** has heard many cases. But her vote for and role in crafting the decision in *Goodridge v. Department of Health*, which allowed same-sex couples to be married legally in the Commonwealth of Massachusetts, will be an indelible part of her legacy as a jurist. The former top lawyer for Harvard University was appointed to the state's highest court in 1996 by Governor William Weld, who knew her through her husband, former *New York Times* columnist Anthony Lewis. Her appointment was met with protests, particularly within the local African American community, because she is a South African by birth and was seen as unsympathetic to some communities. But she rallied and won confirmation. Three years later, when the incumbent SJC chief retired, Governor Paul Cellucci nominated her to be chief justice. Her nomination seemed doomed when Cardinal Bernard Law questioned what he saw as anti-Catholic bias, but once again she won out.

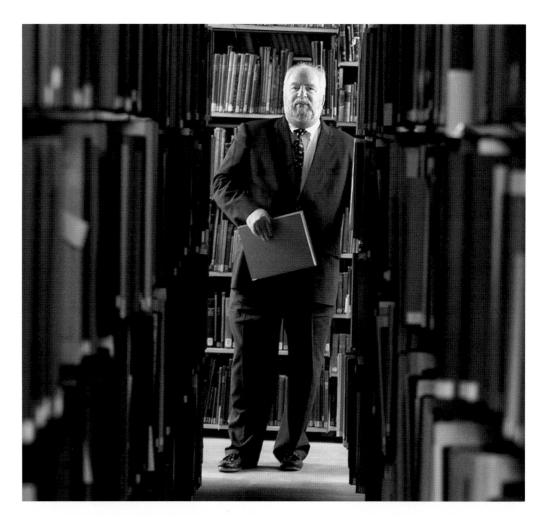

As president of the Boston Public Library, **Bernard A. Margolis** isn't just in the business of loaning out books and overseeing a first-rate research facility. The BPL was the nation's first public library system and is now the country's sixth largest. The Central Library in Copley Square serves as a museum of early Boston history. The building itself, with its famed murals by John Singer Sargent, is a tourist attraction. In his address to the annual meeting a couple of years ago, Bernie summed up the system: "Thirty-three million items later we stand here at Copley Square with almost a million square feet of space in this complex and 27 branch libraries. We now have 10.3 million hits every month to our Web site, and we are probably more virtually accessed now than we are by people walking through our doors. Our collections are enormous, and the range is quite vast, from all of the Audubon folios to Shakespeare's first folio."

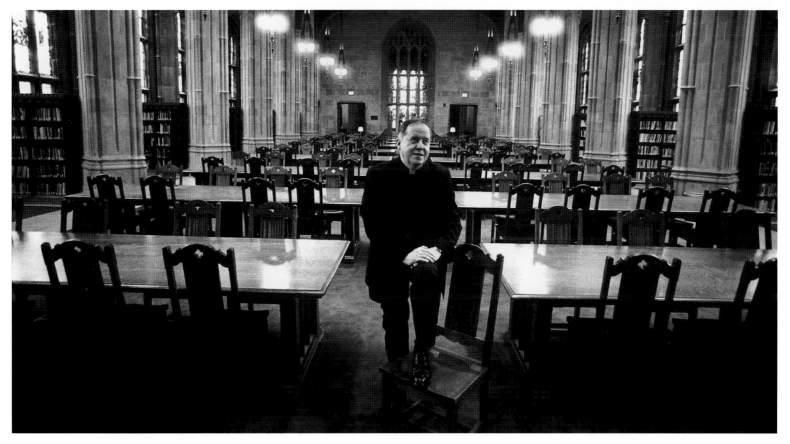

An author and a scholar in twentieth-century American social and religious history, Boston College president **Rev. William P. Leahy**, SJ, isn't your typical university leader. He holds a doctorate in history from Stanford University and a master's degree in divinity and sacred theology from the Jesuit School of Theology in Berkeley, California. He is the author of *Adapting to America: Catholics, Jesuits and Higher Education in the Twentieth Century,* as well as numerous scholarly articles on religious and educational history in the United States. He is a trustee of Boston College and of Loyola University of Chicago, and is a member of the executive committee of the Association of Jesuit Colleges and Universities.

Thomas H. Lee Partners, the prominent private equity firm founded in Boston by **Tom Lee** in 1974, is a unique leveraged-buyout firm. The company has an international reputation for being among the friendliest of companies in a rather unfriendly field. With an estimated $12 billion of capital under management, Tom's operation is known for finding a company that still has potential for growth and for having an eye for a company that can be revamped. Tom's zeal for getting in the mix extends to his other interests and his philanthropic and charitable work, including serving as a cochairman of Harvard's capital campaign.

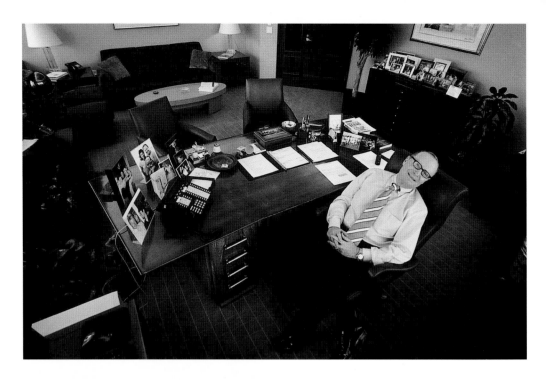

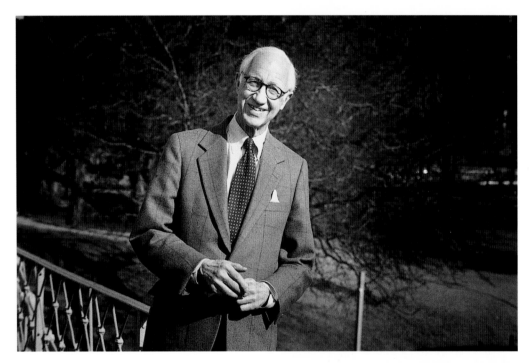

Beacon Hill, the Boston Common, and the Public Garden have a city councilor and a state representative looking out for that part of town, but in **Henry Lee** the area has a lifelong advocate. Whether it's the red brick sidewalks, the famed gaslights, or upkeep of the parks and public facilities, Henry has used his time, energy, and skill to make his corner of the world both livable for residents and enviable for visitors. Among the organizations that have benefited the most from Henry's efforts are the Friends of the Public Garden and the Massachusetts Historical Society.

Veteran New England broadcasters **Loren Owens** and **Wally Brine**, with their booming voices and zany cast of characters, have been holding court on WROR-FM radio each weekday starting at 5:30 a.m. for more than 20 years. While a casual listener may not be sure if the guy calling in from Maine is for real or not, or if what either Loren or Wally is saying is true or not (large parts of their biographies on the station's Web site are parody), one thing is certain. Loren & Wally's show, the longest-running morning show in Boston, is the place where thousands of listeners tune in each morning to kick off their day and get a few laughs while doing so.

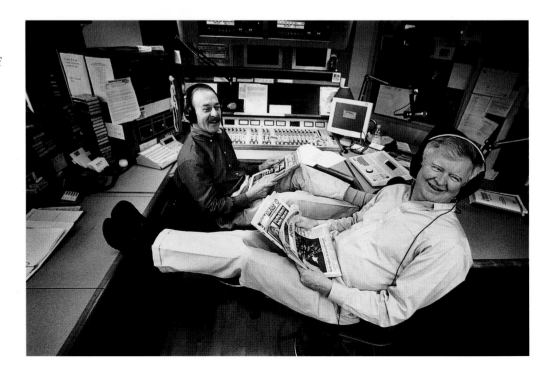

Sheryl Marshall is a rarity in these parts, a woman venture capitalist. A longtime stockbroker and former vice president with Donaldson, Lufkin and Jenrette, she started her own firm, Axxon Capital. (The extra X stands for the female chromosome.) Sheryl has been a big supporter of Boston hospitals and the Institute of Contemporary Art. Those who know her well like to point out that although Sheryl was a major fundraiser for Shannon O'Brien's run for the governor's office, she was part of the Romney transition team.

Maestro James Levine, who just completed his first season as the Boston Symphony Orchestra's music director, was photographed on October 29, 2001, at the press conference introducing him to the city of Boston.

The success of the Lee brothers needs no embellishment. Dr. Thomas H. Lee, a physician, is Network President of Partners HealthCare System and CEO of Partners Community HealthCare. He's also a professor of medicine at Harvard Medical School and an associate editor of the New England Journal of Medicine. William F. Lee is co-managing partner of the law firm Wilmer Cutler Pickering Hale and Dorr LLP. Dr. Richard T. Lee is a physician and associate professor of medicine at Harvard Medical School.

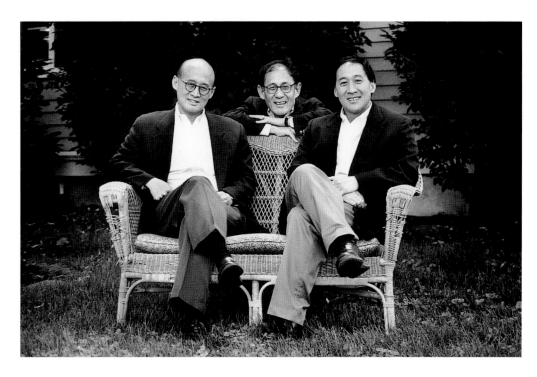

As the first employee of Lycos, founded in 1995, **Bob Davis**, a Dorchester native, knows a few things about taking risks in the world of high-tech. He led Lycos from a company with $2 million in venture capital to a multibillion-dollar business, creating one of the Web's only large, profitable internet companies. In 2000, Bob served as the CEO of the combined company of Terra Lycos and is now a venture partner at Highland Capital. The author of the bestseller *Speed Is Life: Street Smart Lessons from the Front Lines of Business,* Bob donates his author royalties and lecture fees to charity. One of the charities to benefit from Bob's savvy, energy, and largesse is Bridge Over Troubled Waters, which serves Boston-area at-risk youth and their families. His efforts for the organization have turned their annual fundraising campaign into one of the most successful in the city.

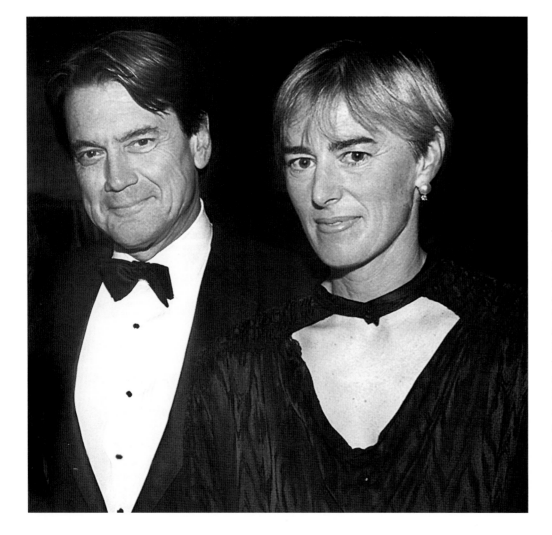

Whether it's Tea Party or Don Law Company or SFX or Clear Channel Entertainment, if it involves **Don Law** it means live music. Now the chairman of Global Music for Clear Channel Entertainment, Don and his staff in Cambridge are behind all the biggest concerts at the region's larger venues. Not a pair to seek headlines or recognition, Don and his wife, **Sara Molyneaux**, were photographed at a fundraising dinner a few years ago for the anti-poverty group ABCD, one of the many charities they have supported.

He became a household name during the 13 years he generated awe-inspiring returns at the helm of Fidelity's Magellan Fund, but now **Peter S. Lynch** and his wife, **Carolyn**, spend most of their time and energy and a great deal of their money on philanthropic efforts in Boston. Lynch is the vice chairman of Fidelity Management & Research Company, the investment adviser wing of the company. Through their personal efforts and the Lynch Foundation, Peter and Carolyn have made education, young people, Boston College, and the Catholic Schools Foundation priorities. A $10 million gift in 1999 to Boston College was given to support the school's teacher-education program, and the School of Education at BC now bears their name.

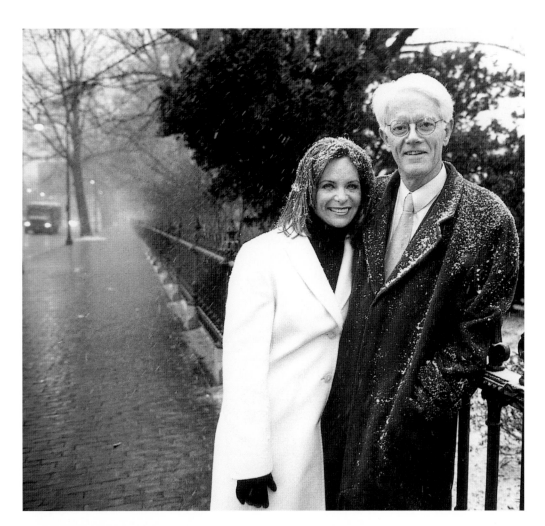

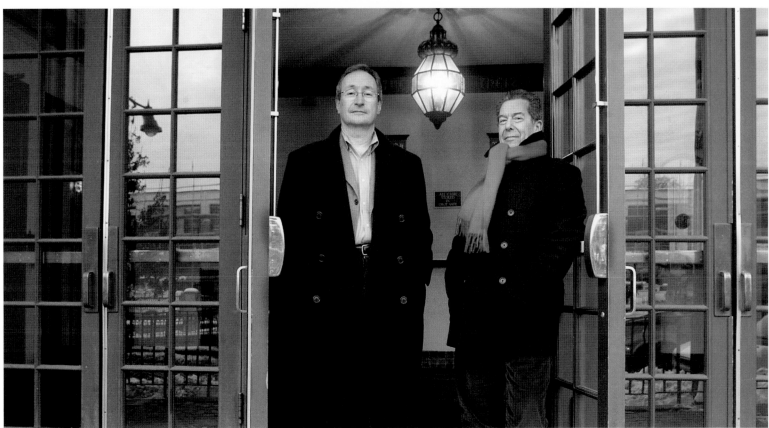

Just when people were saying there wouldn't be any new theaters built in Boston, the Huntington Theatre's managing director, **Michael Maso**, and artistic director, **Nicholas Martin**, proved them wrong. The Stanford Calderwood Pavilion at the Boston Center for the Arts is a shining example of the city working with a local college, Boston University, and a private developer, the Druker Company, to make a formerly vacant corner (in this case, in the South End) one of the city's hottest addresses. Michael has served as the Huntington Theatre's managing director since 1982. As artistic director, Nicky has directed eight productions, including *Butley* and *Springtime for Henry*. He has extensive New York theater credits and was featured as one of the country's most creative people on *Entertainment Weekly*'s "It List."

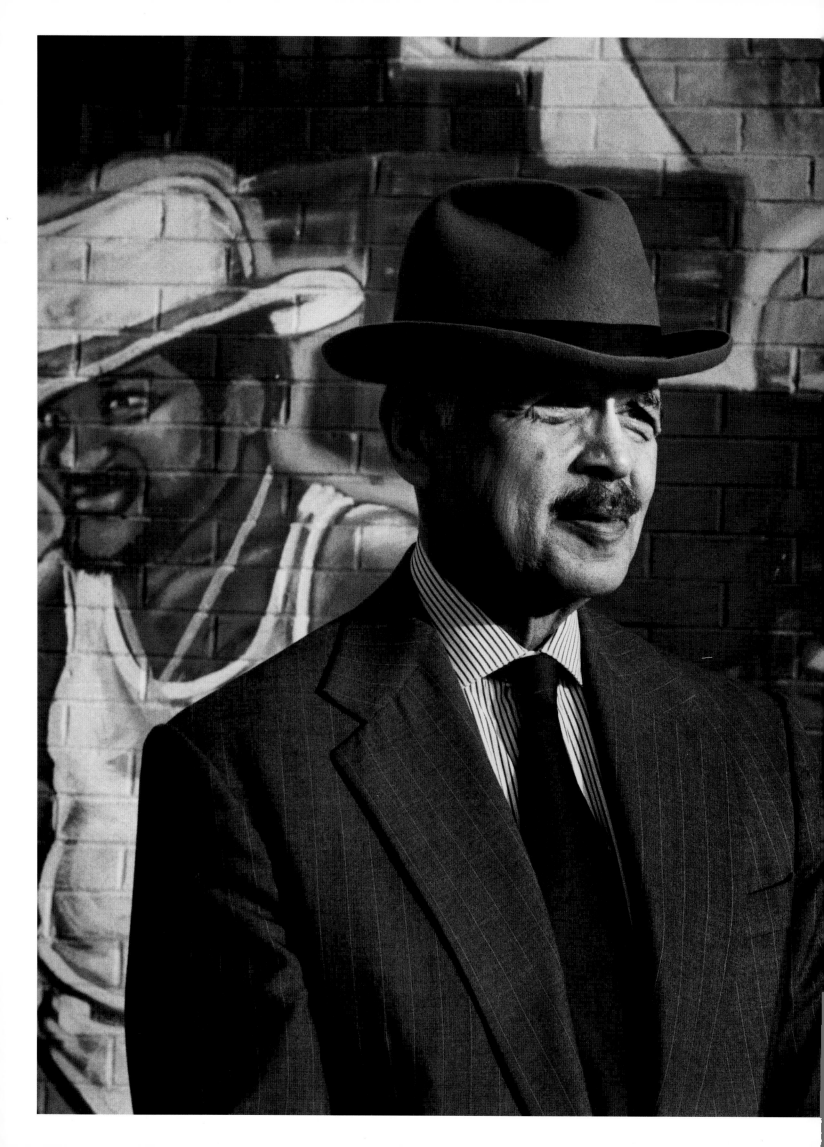

Melvin B. Miller has been the editor and publisher of the *Bay State Banner* since 1965. He has weathered all types of storms at the helm of New England's oldest continually operated black-owned newspaper, often by bucking the trend. When many thought the *Banner* would automatically endorse Mel King's candidacy for mayor in 1983, it was Mel Miller who struck out on a separate course. But he lets his readers know where he's coming from. While participating in a forum with other regional newspaper publishers, he listened as others outlined how news organizations had decided whom to endorse or what issue to champion. In typical Mel Miller style, he responded, "That's far more democratic than what happens at the *Banner*. I decide unilaterally and that's it. I don't get paid much, but I have to have some perks."

This trio of executives from EMC had no problem taking stockholder questions at a meeting in mid-2005. Briefing those gathered at the companys' Hopkinton headquarters were **William J. Teuber Jr.**, executive vice president and CFO; **Joseph M. Tucci**, president and CEO; and **Michael C. Ruettgers**, chairman of the board. With 2004 revenues of $8.23 billion, and nearly 23,000 employees worldwide, EMC is the world leader in products, services and solutions for information storage and management—and among the more philanthropic corporations.

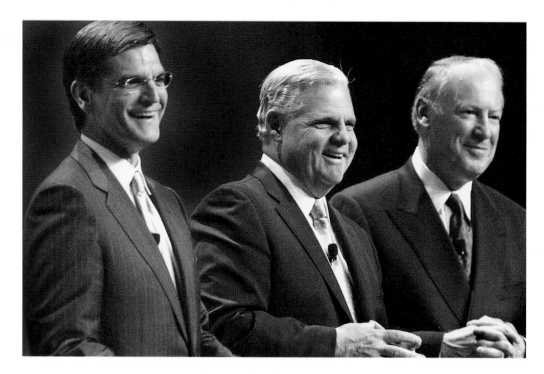

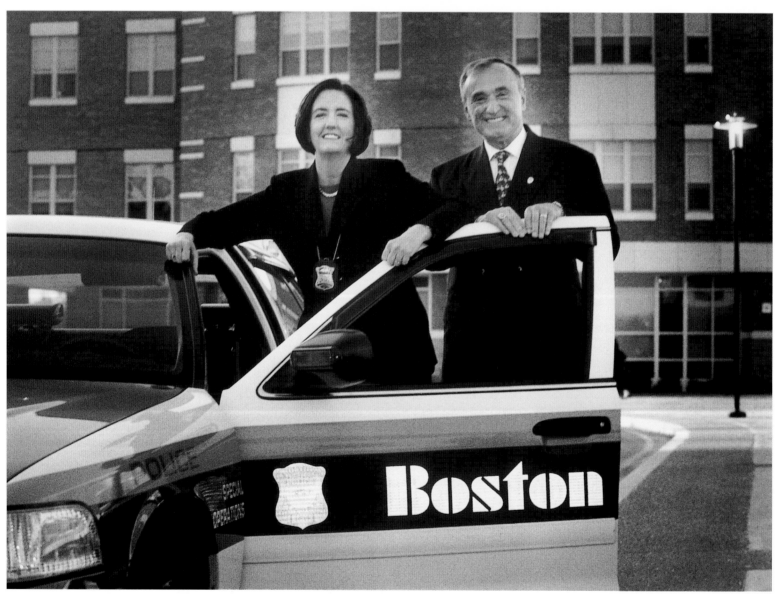

Just moments after she was sworn in at a ceremony at an elementary school in Dorchester, Boston Police Commissioner **Kathleen M. O'Toole** was congratulated by her former boss, **William J. Bratton**. Her tenure hasn't come without its tragedies, and yet she has drawn remarkably few critics. Now the police chief for Los Angeles (and once New York City's top cop), Bill flew in to Boston the morning that Kathy became the first woman to head the department, then went back to the West Coast after a few hours. With much of his family still in Boston, Bill is a frequent visitor to his hometown.

A recent *Boston Globe Magazine* profile said, "The Boston Harbor Association is pretty much **Vivien Li**." And that pretty much sums it up. Vivien's impressive list of accomplishments is long, but here are some highlights: Boston Harbor is cleaner than the Charles River, 90 percent of Greater Boston's ocean beaches are swimmable for nearly all of the summer, and a 43-mile HarborWalk, a seaside promenade, is more than 75 percent complete. While Vivien and her full-time staff carry the clout of their 1,000-plus members, the Boston Harbor Association has a budget of only $300,000.

There really *is* a Mr. Tux—more precisely, it's Ms. Tux and she's **Sheryl A. McKanas**, the woman behind the nearly four dozen tuxedo-rental locations in Boston. Sheryl, who runs the company with her brothers, Marc and Arnold Atkin, is a force of nature when it comes to the busy seasons for formal attire. Led by their father, Sooky Atkin, the family has established a scholarship program that reaches out to high schools and communities that don't regularly benefit from such opportunities. Through Sheryl's considerable energy and efforts, the scholarship program has been expanded greatly.

Whether it's reading to young people for the nonprofit Reach Out & Read, or being the keynote speaker at the Jewish Vocational Services award luncheon, or a having an opinion on a Harvard Business School report on the region's economy, Mellon New England chairman and CEO David Lamere is constantly on the go. A vice chairman of Mellon Financial, David also is president of Mellon's Private Wealth Management group.

It would be easy for **Cathy E. Minehan** to stay in her office that's perched above the city, but the president of the Federal Reserve Bank of Boston is an active member of the business, civic, and philanthropic communities. Not only has she worked hard to make credit available in low- and moderate-income areas, but Cathy also has pushed to open up and demystify the system so that individuals and neighborhoods that have traditionally been locked out of the economic mainstream can have a better chance to succeed. Honored by several organizations in town for her support, Cathy has been at the helm of the Federal Reserve Bank of Boston since 1991. She began her career with the Federal Reserve System in 1968.

Sheila Moore is driven to help those in our community who need help the most. Now the head of Bridge Over Troubled Waters, an agency whose street workers target runaways and homeless youth, Sheila was the executive director of Casa Myrna Vazquez for seven years. Located in the South End, Casa Myrna Vazquez is New England's largest organization dedicated to ending domestic violence through intervention and prevention.

In the Boston area, Biogen is still just a one-word company, but after a merger in 2003, it is Biogen Idec. The combination of one of the world's original biotech companies and a pharmaceutical leader in cancer and autoimmune diseases has created the third-largest biotech company in the world. **James C. Mullen**, a veteran Biogen executive, is the president and CEO of the Cambridge-based company. Jim went off to college thinking he would be a doctor but changed his mind after deciding that he wanted to "use science to solve problems." He received a chemical engineering degree from Rensselaer Polytechnic Institute and an MBA from Villanova University. In addition to his many professional affiliations, Jim is co-chair of the capital campaign steering committee of Cambridge Family and Children's Service.

Famous for starring in their own commercials, this duo has created one of the more successful marketing and business ventures in the Boston area. **Barry** and **Eliot Tatelman** took the furniture store their grandfather started in 1918 in Waltham and built it into a mega-chain that not only sells furniture but also houses rides, 3-D movie theaters, and—in the newest location in Reading—a replica of Fenway Park's Green Monster. Although the brothers sold Jordan's to Warren Buffett's Berkshire Hathaway Inc., they maintain daily control of the stores. As successful as they are in the furniture biz, they are equally as generous, often quietly, for civic and charitable causes in the region, including the American Red Cross and organizations to end homelessness, hunger, and AIDS.

J. Keith Motley, a longtime administrator at Northeastern University, was the interim chancellor at UMass Boston. The first black leader of the Boston campus, he is credited with enlivening the campus and working to create a stronger identity for the 11,700-student commuter school. A finalist for the permanent chancellor's position, Keith remains on campus as Vice President for Business and Public Affairs.

Most people in Boston first meet **Soosie Lazenby** at a gala function where she has a clipboard in her hands and an earpiece connecting her to every detail of the event. In 2001, Soosie founded Sports & Entertainment Matters Inc., where she drew on her experience of making sports work in private, public, and not-for-profit sectors. Having sold her company, she is now a vice president of brand strategy for Jack Morton Worldwide and chair of the Governor's Committee on Fitness and Sports.

Boston's one of those lucky cities to have two independent newspapers. The Purcell family keeps the *Boston Herald* scrappy and things interesting. From left, they are: **Erin E. Purcell**, executive vice president, Herald Interactive Inc.; **Gregory R. Rush**, chief operating officer and associate publisher, Community Newspaper Company; **Kathleen B. (Purcell) Rush**, publisher, *Parents & Kids Magazine*; **Kerry A. Purcell**, staff writer, *Boston Herald*; and patriarch **Patrick J. Purcell**, President, Herald Media Inc. Patrick J. Purcell Jr., the *Herald*'s display advertising manager, is missing from the photograph.

One hot night in June 2004, there was a packed house at Great Bay Restaurant at the Hotel Commonwealth to welcome the new owners of the Los Angeles Dodgers. The locals hadn't lost their love of the Red Sox, nor had they lost their affection for Boston developer **Frank McCourt** and his wife, **Jamie**, since the couple bought the National League franchise in early 2004. In this photograph taken on Commonwealth Avenue are, from left, Dodgers vice chairman Jamie McCourt, the highest ranking woman in pro sports; Dodgers owner and chairman Frank; his brother, **Richard**; and Richard's wife, **Ginger**.

People know **Dave McLaughlin** from his screenplay for the movie *Southie*, but it's for his hustle in getting stage plays produced that many in the arts community have come to appreciate him. "My main thought is that *Southie* may be the least important piece of writing I've done," Dave said. Whether it's pulling together actors and rounding up an audience for a reading of a fellow playwright's work or promoting someone else's production, Dave sees his job as preserving history. "Many Boston Irish Americans have sort of lost touch with the form, and yet it's a perfect form for a culture that is so full of oral storytelling.

A funny thing happened on the way to the fundraiser. **Lenny Clarke** and **Denis Leary**, two comic actors who got their start working the local circuit, now appear in numerous television series and feature films. (Clarke hails from Cambridge, Leary from Worcester.) The two friends have been cracking each other up for 27 years, as in this photograph taken during the warmup sessions for a charity hockey game to benefit the Leary Firefighters Foundation. Denis started the foundation five years ago after six Worcester firefighters, including Denis's first cousin Jerry Lucey, were killed when a fire swept through an abandoned warehouse.

The Leary brothers have been quietly making their mark. **Joseph F. Leary Jr.** is president and CEO of the Irish American Partnership, a non-profit charitable corporation organizing Irish American support for job creation, economic development, and education in both the Irish Republic and Northern Ireland. **Kevin W. Leary** is the founder and president of VPNE Parking Solutions, a valet parking and transportation company that provides services to New England hospitals. Kevin's charitable work includes 10 years as president of Family Continuity Programs and his service as a trustee of Nativity Preparatory School in Jamaica Plain.

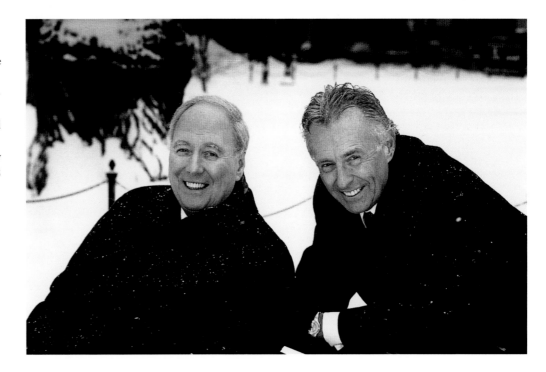

As president and director of the Museum of Science, **Ioannis "Yannis" N. Miaoulis** makes sure young people have fun while they learn. When he was dean of Tufts University's School of Engineerng, from 1994 until 2003, he made sure young people learned while they had fun. Among the many innovations at the museum is an expansion of its National Center for Technological Literacy, aided by $6.5 million in federal money. The center will include hands-on exhibits where museum-goers can play "engineer for a day." "The museum will be a proto-type for the [other] museums and how you bring in technology in an equal way to science," Yannis told a *Boston Globe* reporter. "Technology has advanced tremendously, but people have no idea how things are being made, and part of the reason is that the school curriculum focuses on the natural world and not the human-made world."

Thomas J. May is chairman, president, and CEO of NSTAR, Massachusetts's largest investor-owned electric and gas utility. Tom is a busi-ness leader who rolls up his sleeves and gets involved. A director of several businesses, he also is a trustee of Stonehill College and the Dana-Farber Cancer Institute. He is active in leadership roles in several civic and business organizations and is the past chair of the Governor's Board of Economic Advisors, the Massachusetts Business Roundtable, and the United Way Campaign. In 2004, Tom was hon-ored by the Boy Scouts of America's Minuteman Council.

"On time and within its legislated budget" is how **Jim Rooney** describes the new Boston Convention & Exhibition Center in South Boston, the largest building ever constructed in New England. Jim is the executive director of the Massachusetts Convention Center Authority, which oversees the new convention center, the Hynes Veterans Memorial Convention Center in the Back Bay, the Boston Common Parking Garage, and the Springfield Civic Center, which is being renovated and expanded and is slated to reopen in fall 2005 as the MassMutual Center. Previously, Jim was the Authority's Director of Development and Construction, overseeing the building of the 2.1 million-square-foot South Boston facility. Prior to joining the Authority, he was chief of staff to Mayor Thomas M. Menino.

Since becoming president of Lesley University in 1985, **Margaret A. McKenna** has built on the school's reputation as a premier institution for training educators. With a budget of $90 million and a student enrollment of 10,000, Lesley is the largest provider of graduate education to classroom teachers in the United States and the ninth-leading provider of master's degrees in the country. Before joining Lesley, Margaret was director of the Bunting Institute and vice president at Radcliffe College, White House Deputy Counsel to President Jimmy Carter, and a deputy undersecretary in the U.S. Department of Education. Prior to her government service, she was executive director of the International Association of Human Rights Organizations and a trial attorney with the Civil Rights Division of the U.S. Department of Justice.

When philanthropist **David Mugar** owned the Channel 7 television station in Boston, he was credited with using the latest technology and forming partnerships that made the station competitive with the more established news operations in town. Later he would apply that same drive and zeal to revolutionizing how people viewed the city's annual Fourth of July celebration. As one national broadcaster put it, what the late Boston Pops conductor Arthur Fiedler did for the music on the stage, David Mugar did for the rest of the evening's magic. No detail is too small for David to cast his eye upon. As a result, millions of people over the years have enjoyed the dazzling holiday fireworks display—which is now televised worldwide.

There might be a non-politician in the city of Boston who is as adept at working a room as **Frances K. Moseley**, but it's unlikely. Truth be, Frances could teach most politicians a few things about raising money and making connections. Now the president and CEO of Boston Partners in Education, a not-for-profit that places some 1,300 volunteers in 100 Boston schools, she continues the work she began as head of the Boys & Girls Clubs of Boston. After 20 successful years in the private sector, Frances took what she learned and applied that business strategy to her nonprofit endeavors.

He's the owner of the Union Oyster House, the country's oldest restaurant, but **Joe Milano** doesn't fit neatly into the category of restaurateur. In addition to running the historic eatery that has become a must-stop for tourists, Joe serves as honorary consul general of the Kingdom of Thailand for Boston and as a director for the Greater Boston Association for Retarded Citizens and other charities.

Scott Neely and his brother, Bruins Hall-of-Famer **Cam Neely**, lost their parents, Marlene and Michael, to cancer, but they weren't going to let the story end there. Along with their sisters, Christine and Shaun, they started the Neely Foundation, which has raised more than $11 million for charitable endeavors. Among the most tangible successes was the opening of the Neely House at the Tufts-New England Medical Center in 1997. The house is located within the medical facility and is run like a bed and breakfast–style home away from home for cancer patients and their families. It has already helped nearly 600 families.

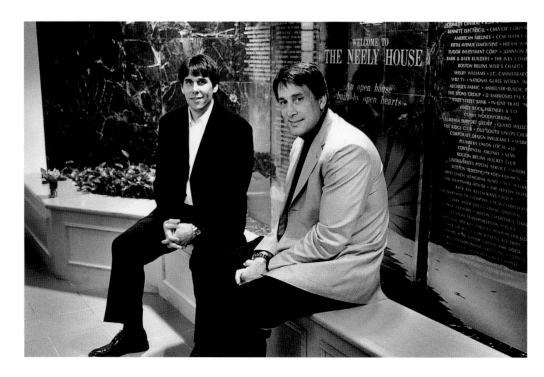

Norman Pashoian came to the Ritz-Carlton, Boston, in 1947, and was trained as an elevator operator. He soon worked his way up to bellman, back in the days when luggage was never carried by hotel guests (and when there were no luggage carts). Recognizing Norman's ability to make guests feel welcome and at ease, the hotel's owner, Edward N. Wyner, made Norman the regular doorman at the Newbury Street entrance. (He now works at the main entrance on Arlington Street.) Over the years, Norman has lived the Ritz-Carlton motto: "We are ladies and gentlemen serving ladies and gentlemen."

Managing editors run in the Mulvoy family. Sitting on the front steps of their boyhood home at 22 Lonsdale Street, Dorchester, are **Tom Mulvoy** and **Mark Mulvoy**. Tom was managing editor at the *Boston Globe* from 1986 until his retirement at the end of 2000 after more than 34 years with the paper. Mark was managing editor of *Sports Illustrated* from 1984 until he retired at the end of 1996 after 31 years with the magazine. The steps lead to the first-floor, five-room apartment where Tom and Julie Mulvoy raised their five children—Mark, Tom, Bob, Mary, and Jim—in the 1940s and 1950s.

When several of Boston's largest and oldest law firms were bought, merged, or closed, the city's attorneys were being scouted for jobs with national firms elsewhere. It is **Regina M. Pisa**, chairman and managing partner of Goodwin Proctor LLP, who is credited with wooing and winning over many of those attorneys, persuading them to stay in Boston and work for her firm. Regina manages more than 650 attorneys, which makes Goodwin Procter one of the largest law firms in New England. She serves as a trustee or on the board of several organizations, ranging from the Massachusetts Women's Forum to Dimock Community Health Center to the Somerville Museum.

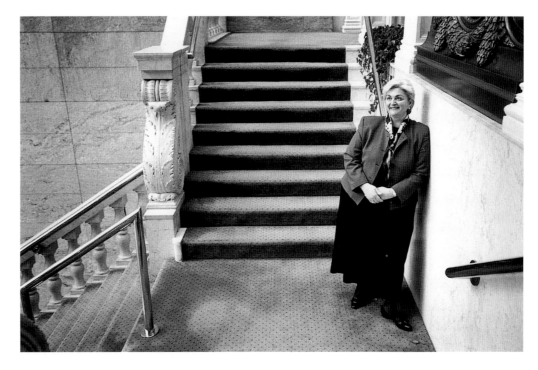

Professor **Thomas H. O'Connor** wrote the book on Boston. A Boston College professor and American history scholar who served for eight years as department chair, Tom carries the title of professor emeritus and school historian. But don't let the titles fool you. Tom has published numerous books about the city and its people, and he continues to write about, teach, and study the ways, means, and traditions of the Puritans' old town.

Dennis Lehane is an overnight sensation who was 20 years in the making. Anyone who followed the local fiction scene witnessed the success that he built over the years from *A Drink Before the War* through *Shutter Island.* Dennis's *Mystic River* was a finalist for the PEN/Winship Award and won the Massachusetts Book Award in Fiction. The much-chronicled transformation of *Mystic River* to an Oscar-winning film brought more fame, but Dennis still writes and teaches. Born and raised in Dorchester, his writing reflects an intimate knowledge of his hometown.

When **Ted Cutler**, right, and his wife, Joan, ask people to turn out for a fundraiser, they come. And they come until the ballroom at the Four Seasons Hotel is sold out. The Cutlers got involved with fundraising in a big way when their son, now grown, was diagnosed with Crohn's disease at age 9. That involvement has grown into the annual Crohn's & Colitis Foundation of America's ball at the Four Seasons, which every year breaks local (unofficial) records for the amount of money raised for a charity in one night. Other charities that the Cutlers have supported include Ted's alma mater, Emerson College, the Cutler Majestic Theatre, and the Boston Medical Center. Joining the Cutlers at a recent gala were **R. Robert Popeo**, left, and Four Seasons general manager **Peter O'Colmain**. When Bob isn't fulfilling one of his many philanthropic commitments, he is chairman and president of the Boston law firm Mintz Levin.

The eyes don't deceive. Yes that's the front man for Boston's Hall of Fame rock band Aerosmith, **Steven Tyler**, hamming it up with Hall of Fame hockey legend **Bobby Orr**. Outside the locker rooms before a charity hockey game to benefit the Leary Firefighters Foundation, Steven, who sings a version of the national anthem that brings goosebumps, and Bobby, a celebrity coach, show they are both good sports when it comes to charitable efforts.

Colette Phillips says she keeps a globe in her office to "remind me that we live in a globally diverse community, not just in Boston. Our world cannot be just Boston." Originally from Antigua, Colette has her own company, Colette Phillips Communications, the oldest and largest communications firm run by a woman of color. Her clients, however, run the gamut from corporate to charitable to civic to sports.

Whether it's transforming Gillette Stadium for an anniversary or creating an exotic Moroccan bazaar or helping people forget they are in a hotel ballroom during a New England blizzard, **Bryan Rafanelli** has mastered the fine art of making people feel like they are in another time or place. A Boston native, Bryan studied design at the Boston Architectural Center and turned that training, his eye for detail, and his dazzling creativity into one of the most successful event-planning companies in the region, Rafanelli Events.

Bill Brett had *Boston Globe* sports columnist and national sports commentator **Will McDonough** and his son, sports announcer and former voice of the Red Sox **Sean McDonough**, on his list for this book from the beginning. When Will, his longtime friend and colleague, died unexpectedly, Bill thought he'd lost his chance for a memorable portrait. But by blowing up a photograph of Will that hangs in the *Globe*'s sports department, Bill and Sean were able to make it happen. "Not only did I love the photograph, I made Bill give it to me. It's in my office, I talk to it everyday," said Sean, who announces games for ESPN. Will wrote a much-missed weekend column that was the bible of the local sports world. Sean and Will's family continue their tradition of supporting community charities, especially any organization that helps people live a better life. "My family has been committed to returning to the city the support it gave us," Sean said.

When former New Kid on the Block **Joey McIntyre** returned to Boston as the star of *tick, tick . . . BOOM!* his father, **Tommy**, loaded up a couple of buses with family and friends so that they'd all have a chance to see the performance. That's how much Tommy supports his son. When Bill Brett stopped Tommy, now retired as an official with the Bricklayers Union, in the spring of 2004 and told him he'd like to take his picture the next day, the elder McIntyre wondered why. Bill explained that Joey was due in from California the next night. The father called his son and found out that yes, he would be in town to collect an award. Bill took this photograph as Joey was about to attend the function at the Ritz-Carlton, Boston.

Thomas Phillip "Tip" O'Neill Jr. was as comfortable walking the halls of Congress as he was catching up with old friends in North Cambridge. Bill Brett took this portrait in the mid-1980s as a tax issue was being debated in Washington. But in those days, and particularly under Tip's leadership, battles were mostly fought on the floor and weren't often carried outside or beyond the political debate. Despite all his success in Washington, what mattered most to Tip were his early accomplishments (like his time as a Realtor or when he served on the Cambridge School Committee or in the Massachusetts Legislature), his family (including the achievements of his son Tom), his church (St. John the Evangelist), and his neighborhood.

Formerly a lieutenant governor and state legislator, **Thomas P. O'Neill III** now puts his years of public service to use as CEO of O'Neill and Associates, a public relations, marketing, and lobbying firm. Based in Boston, Tom oversees all aspects of the company and client servicing. He continues in his family's tradition of building bridges between communities. "The City of Boston itself is a great family where there are many different clans and tribes," Tom said. "The O'Neills are proud to be part of the 'family' of Boston where people have more in common than not."

There really are Murphys at the Murphy Funeral Home. The Dorchester company is led by brothers **Paul J.** and **James T. Murphy**, center, flanked by James's sons, from left, **Brendan T.**, **James K.**, **Thomas P.**, and **Patrick T. Murphy**. The fourth generation now carries on the long, proud tradition at the funeral home, which has helped thousands of Boston families over the years. The Murphys even deftly handled Hollywood when they were part of the film *Mystic River*, but it wasn't their first brush with Hollywood. In the early 1980s Sidney Poitier filmed for several days with the Murphys when he was making *Hanky Panky* with Gilda Radner and Gene Wilder. "Oh yeah, we're real famous," joked Jim, the family patriarch. In one Boston neighborhood, at least, they are.

As executive vice president for Meredith & Grew, **Kevin C. Phelan** is a member of the executive committee, and a director and partner of the firm. His 13-person team produces more than $600 million annually in loans. Kevin has opened many doors for newly transplanted or recently returned business leaders through his "Breakfast Club." It is among the most coveted invitations one can receive. Kevin is a supporter of numerous civic and charitable causes.

Stephen Mindich is the old-fashioned kind of newspaper owner-publisher: the sort who is involved in every aspect of his businesses. He is the head of the Phoenix Media Communications Group, which includes the flagship *Boston Phoenix,* the *Portland Phoenix,* the *Providence Phoenix,* and radio station WFNX. Outside of the paper, where he has worked since 1966, Steve is a supporter of the Institute of Contemporary Art, the Museum of Fine Arts, and the American Repertory Theatre. Steve and his wife, former Superior Court Judge Maria Lopez, are active in Provincetown, with the film festival, the new theater, and the Fine Arts Work Center.

Joseph O'Donnell is one of those people who keep Boston running—and not just through his ownership of the Boston Culinary Group, whose 12,000 employees service stadiums and sporting events, cinemas, ski resorts, ferry services, restaurants and airport cafes, and other venues. Recently named by *Boston* magazine as the most powerful person in Boston, he regularly attends all kinds of social and charitable events. But it is the Joey Fund, which Joe and his wife, Kathy, founded in honor of their son, Joey, who died at age 12 of cystic fibrosis, that is the primary focus of their philanthropic efforts. A graduate of Harvard College and the Harvard Business School, Joe started his first concession business while still in high school, renting out tuxedos for the prom at Malden Catholic. While at the B-school, he started a service to help minority students find housing, which led to an ongoing university program. Joe has endowed Harvard's baseball program with a $2.5 million gift, and in 1997 the school named a field in honor of its former baseball and football standout.

Robert B. Parker is the dean of New England's hardboiled mystery fiction, with nearly four dozen titles that have danced across the bestseller lists since the early 1970s. He's best known for his famed Spenser novels, which spawned the popular television show *Spenser: For Hire* that was filmed in Boston in the 1980s. Bob has also charmed and entertained readers with his novels about Sunny Randall and Jesse Stone and his latest and darkest character, Joseph Burke. *Publisher's Weekly* said Bob "writes ceaselessly about male bonding, codes of honor, and hard men doing hard things." And while Bob is a brilliant man writing brilliant books, he's merely one half of one of the most formidable, interesting, and effective couples on the social and philanthropic circuit. Bob and his wife, Joan Parker, have championed causes that include the American Repertory Theatre and Community Servings.

Don Rodman made his name as the president of Rodman Ford Sales. But he has built a legacy through his 1991 founding of the Rodman Ride for Kids, an annual biking event that has raised more than $10 million for organizations serving at-risk children. Shown here fresh off finishing the 13th annual ride, Don organized the event as a healthy way for people to raise money for others. The ride, which kicks off from and ends at the Rodman Health Center in Foxborough, lets participants choose either a 25-, 50-, or 100-mile event. Don is active in the community, serving on the boards of the Colonel Daniel Marr Boys and Girls Club, Catholic Charities, the Robert F. Kennedy Action Corps for Children, Friends of Wrentham, the Ron Burton Training Village, the Red Auerbach Foundation, and the Police Activities League.

Either fiercely loyal or just plain fierce—that's how one might describe **George Regan**. It all depends on whether you're a friend or an adversary. And which issue you are talking about. Whenever major action is going on in the city, you can bet George is involved on one side or the other. His first foray into the inner workings of Boston came when he went to work as press secretary for his mentor, Mayor Kevin White. When White chose not to run again in 1983, Regan founded the company that bears his name, Regan Communications Group. He counts among his clients some of the biggest companies in the city, with acquaintances reaching to the highest levels of the Commonwealth and beyond.

It was a festive turnout when **Jackie Jenkins-Scott** was inaugurated in April 2005 as the 13th—and first African-American—president of Wheelock College. "Each day, I have the privilege to work with people who are devoted to creating a caring learning environment where students are challenged to become critical thinkers and global citizens," she writes in her welcome letter at the College's Web site. "At Wheelock we are all committed to our mission of improving the lives of children and families, and we know that there are unlimited ways to achieve this goal." Jackie previously served as president and chief executive of Dimock Community Health Center in Roxbury. She also has held several positions in the state's Departments of Public and Mental Health.

It's all in the family for the Rappaports, and among them they have every aspect of real estate covered, from investing through development. **Jerry Rappaport**, center, has been a mover and shaker in the city for more than 50 years. In 1993, he and his two sons, **Jerry Jr.**, left, and **Jim**, founded New Boston Fund Inc., a premier provider of real estate investment, development, and management services, with a portfolio totaling more than 12 million square feet and valued at more than $1.2 billion. Rounding out the family are **Lori**, wife of Jerry Jr.; **Phyllis E. Rappaport**, a company director and chair of the charity, the Jerome Lyle Rappaport Charitable Foundation, which she founded with her husband and his sons; and Jim's wife, **Cecelia**.

Robin Brown, **Julian Cohen**, and **Stephen R. Weiner** stand with a model of the new Mandarin Oriental Hotel & Residences, slated to open next to the Prudential Center in 2007. They are the C, the W, and the B in CWB Boylston, developers of the $260 million, 450,000-square-foot complex, which will include a five-star hotel, luxury condominiums with starting price tags of $2 million each, a spa, restaurants, and high-end retail shops. The project was conceived by Robin, former general manager of Boston's Four Seasons Hotel. It taps into the experience of Julian, a pioneer who has built shopping centers throughout New England for 50 years, and Steve, whose company, S. R. Weiner and Associates, counts more than 16 million feet of commercial space among the properties it owns or manages.

It seems so natural a course that you might think Governor **Mitt Romney** mapped it out years ago. After all, Mitt's father, George Romney, was a successful businessman, a three-term governor of Michigan, and a champion of volunteerism. Mitt turned his remarkable business career, particularly at Bain & Co., into service as president and CEO of the Salt Lake Organizing Committee for the 2002 Winter Olympics at a time when the effort was $379 million in debt. By mobilizing an unprecedented number of volunteers, and by working productively with the federal and state governments, he helped turn the Winter Games into a huge success.

No, really, his name *is* Uncle Sam and he can prove it. Born **Leroy "Sandy" Rounseville**, the Quincy real estate agent had his name legally changed to Uncle Sam. Not only does his driver's license list his name as Uncle Sam, it carries a picture of him wearing the traditional "I Want You" red, white, and blue garb. Uncle Sam has put a couple of decades of work into his patriotism and is officially recognized by the town of Arlington, which is the birthplace of the historical figure Samuel Wilson, who is thought to be the inspiration for "Uncle Sam."

Theater producer **Jon B. Platt** has had a staggering string of successes—both commercial and critical. Broadway in Boston, which produces shows out of the Charles Playhouse, the Colonial and Wilbur theaters, and the recently renovated Opera House evolved out of American Artists, the theater production company that Platt sold to SFX Entertainment in 1998. It is now owned by the theatrical division of Clear Channel Entertainment. Bill took Jon's portrait in front of Boston's Colonial Theatre, but he had yet another winner with the smash hit *Wicked* at the George Gershwin Theatre in New York City.

Seated on the grand staircase just inside the main entrance of the Museum of Fine Arts, **Malcolm Rogers**, the Ann and Graham Gund Director of the museum since 1994, is in a rare moment of rest. Malcolm's years at the helm of the encyclopedic museum have been a whirlwind of exhibitions and innovations aimed at opening up the Huntington Avenue institution that has served as an anchor for the area's revitalization. Among the highlights of Malcolm's tenure are longer viewing hours (the West Wing was open for 24 hours during an exhibition of John Singer Sargent's works) and lower ticket prices to attract younger viewers. He added popular shows such as "Dangerous Curves: Art of the Guitar" and a "Wallace & Grommit" film series and more traditional shows of the works of Monet and Gauguin. Several of the exhibitions broke box-office records.

Kenneth K. Quigley Jr., president of Curry College, is a case of "local boy makes good." A graduate of Milton High School, he went to the Boston College School of Management and Villanova University School of Law before returning to his hometown to join the Curry faculty. In 1996, Ken became the 14th president in the history of the 125-year-old school. During his tenure, Curry College has seen student enrollments grow by nearly 50 percent, has completed an aggressive building campaign, and has added both undergraduate and graduate degree programs.

Bill Rodgers, four-time winner of both the Boston and New York City marathons, relaxes at his store in the Faneuil Hall Marketplace during the summer of 2004. He lectures and makes appearances around the country but still makes his home in the Boston area. Often called "Boston Billy" during his competitive years, he says he likes to spend time at the store whenever he can because it gives him an excuse to talk about running and racing with avid runners, Boston Marathon fans, and other enthusiasts who stop by.

In the mid-1970s, John B. Pearson, a Boston-born, aspiring major league pitcher, changed the course of his professional life, something that would alter the way mentoring is done in Massachusetts. After completing his undergraduate studies, John took a sabbatical from baseball to serve as a relief worker in war-torn Nicaragua. In 1984, he came to lead Big Brothers of Massachusetts Bay, which under his leadership became the largest male mentoring program in the country. During his tenure, John has been responsible for more than 40,000 one-to-one long-term adult-child relationships.

Boston television news veteran **Emily Rooney** and her father, **Andy Rooney,** the famed curmudgeon commentator on *60 Minutes,* posed for their portrait on the set of *Greater Boston,* the news and public affairs program Emily hosts on WGBH-TV. A former news director for WCVB, Emily was executive producer of ABC's *World News Tonight with Peter Jennings,* and worked for Fox Network in New York. Andy's weekly "few minutes" have ripped through nearly every imaginable subject, from the cotton in aspirin bottles to the international media's reaction to the death of Pope John Paul II.

Mario Russo was born in Formia, Italy, where his grandmother cultivated olives for olive oil, which she used as a cure-all for hair and skin ailments. The boy may have left the Italian countryside behind, but the lessons remain. Pick up any of the products in Mario's hair or skin-care line and see a litany of natural ingredients—and, yes, a lot of olive oil. Mario's number is a must-have for the city's biggest visitors, whether they are royalty or just regular folk. The only complaint from anyone sitting in his chair is that he cannot be hurried—and that's if you're lucky enough to get an appointment at his Newbury Street salon.

You are as likely to see **Darryl Settles** at a Little League game, shopping in SoWa, or working on the BeanTown Jazz Festival as at Bob's Southern Bistro, the Columbus Avenue restaurant he bought, local legend has it, without having set foot in it. Some skeptics thought Darryl, who made a name for himself in the public sector as an appointee of former Governor William F. Weld, might not be the right kind of guy to run the famous eatery, once called Bob the Chef's. Yet he not only succeeded, he surpassed even his own expectations, growing the restaurant's Jazz Café first into the South End Jazz Festival and then into the citywide BeanTown festival.

Bill Walczak co-founded the Codman Square Health Center in the 1970s and has served as CEO of the Dorchester multi-service institution since 1980. The health center has become a major provider of medical and other clinical services, as well as of job training, civic health, education, and youth and community services. With 250 employees, it serves more than 20,000 people through more than 120,000 annual visits. Bill also is founding president of Codman Academy Charter School, a high school located on the health center campus. But his work goes beyond the borders of Codman Square. He has worked on international programs in South Africa, Northern Ireland, and Vietnam, and has worked with other health centers and Boston's medical and hospital community to build programs that benefit all of Boston.

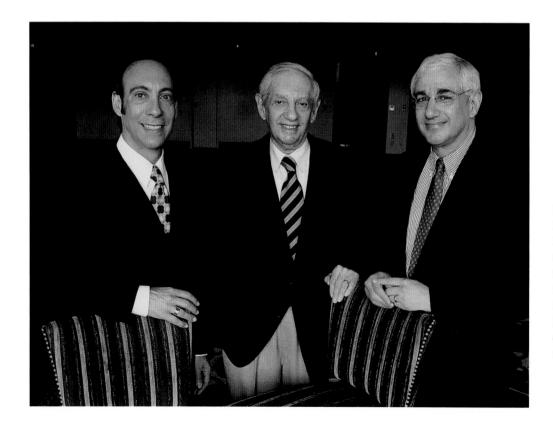

Bob Sage, center, and his brother, **Bill**, right, have been joined by Bob's son-in-law **Mitch Muroff** in the family business of running hotels. Sage Hotel Corp. has several hotels in the area, run under a variety of flags. Their Howard Johnson's on Boylston Street, thanks to the success of the Red Sox, is one of the most booked hotels in the city.

As director of the Laboure Center in South Boston, **Sister Maryadele Robinson** oversees an astonishing array of programs and services. While many not-for-profit organizations focus on one segment of a community, the Laboure Center covers the entire lifespans of its neighbors. The multi-service agency, which falls within Catholic Charities, provides services each year to more than 6,500 infants, children, teens, families, and elders in South Boston and the South End.

Mary Richardson and *Chronicle* co-host **Peter Mehegan** pose with the famed Chevy, which should get a co-hosting credit for all its travels throughout New England. Peter has been with the WCVB-TV show since August 1982, shortly after it premiered as the "nation's first locally produced nightly newsmagazine," and Mary joined in 1984. In mid-2005, Peter announced he would be stepping down by the fall after 41 years of covering news. In making the announcement, he said: "I know I have the best job in the world." The newsmagazine format allows *Chronicle* to do longer segments, sometimes dedicating a whole show to a single topic.

When the WorldBoston Organization chose **Rev. Charles R. Stith** as recipient of the 2003 International Citizen Award, many realized there could be no better choice. As ambassador to Tanzania under President Bill Clinton and founder and director of Boston University's African Presidential Archives and Research Center, a residency program for past African heads of state, Charles reached beyond Boston to make lasting connections around the world. "Our country is in a unique position to convince the world that diversity can mean harmony. But we are not there yet," he told the Boston University student newspaper after receiving the award. In 1985, Charles founded the Organization for a New Equality (ONE) with the central purpose of achieving economic equality for women and people of color. In 2001, ONE recognized Charles's leadership of the organization, awarding him its Medal of Hope for outstanding service at home and abroad.

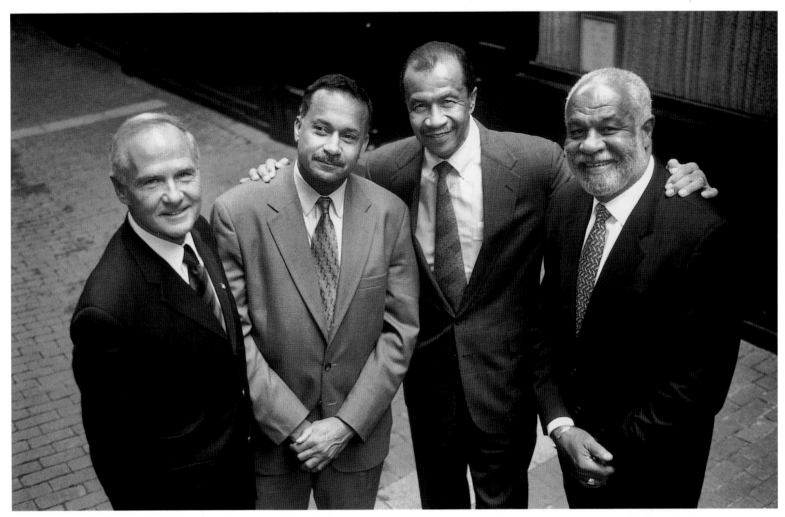

These four well-known lawyers once practiced with the same firm: Budd, Reilly and Wiley, which they started in the late 1970s on Winter Street in the heart of Boston. State Attorney General **Tom Reilly** previously served as Middlesex County District Attorney. **Ralph C. Martin II**, formerly the Suffolk County District Attorney, is a partner at Bingham McCutchen LLP. **Wayne A. Budd**, senior counsel for Goodwin Procter LLP, previously was an associate attorney general of the United States and U.S. Attorney for Massachusetts. And **Fletcher "Flash" Wiley** has concentrated his practice in corporate and commercial law. In 1965, Flash was the fifth African American graduate of the Air Force Academy and the academy's first Fulbright Scholar. While all four have done pretty well since, Wayne said they miss those days: "It was one of the best times of all of our lives."

Founder of the office supply store Staples, **Tom Stemberg** wanted his portrait taken in one of the company's superstores, near corporate headquarters in Framingham. And why not? Tom is credited with inventing the concept of the office superstore and being among the first to pair Internet sales with brick-and-mortar locations. In 2004, Staples had some 65,000 employees in 21 countries and $14.4 billion in sales. In early 2005, Tom decided to step down from his company's board of directors, saying he wanted to pursue new opportunities.

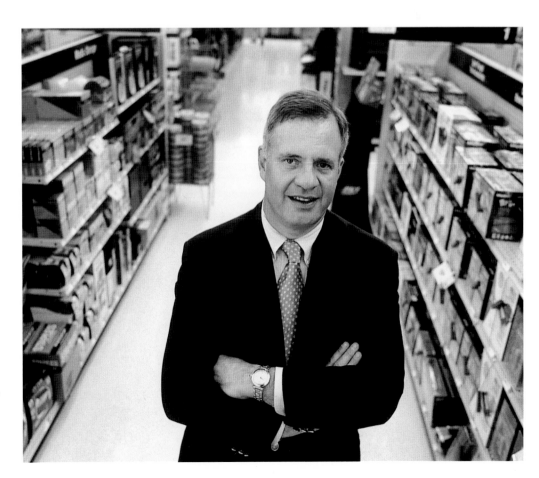

Boston magazine's **Daniel E. Scully Jr.** is a business leader who truly worked his way up through the ranks. He started in 1984 as newsstand sales manager and was ultimately named publisher. A member of numerous boards and organizations, Dan can often be seen in a suit and tie at the opening of the latest hot restaurant or in jeans yelling for the Red Sox. "Boston, the city, has been in my veins since I was born," he said. "So it is a special thrill, and huge psychic income, for me to oversee *Boston,* the magazine, and to be able to use its pages and its resources to give something back to a place that means so much to me."

Raytheon chairman and CEO **Bill Swanson** is the leader of a global technology company that has been based in greater Boston since its founding in 1922. He was Raytheon's first executive diversity chairman and is a passionate advocate for math and science education. "Math and science are the enablers of technology—and career and economic growth," he and legendary Boston Celtics center Bill Russell wrote in a *Boston Globe* op-ed piece. "We must do everything we can to encourage minorities and young women to study these subjects and to enter the fields of engineering and science, which promise so much opportunity."

Alan D. Solomont chose to have his portrait taken on the campus of Boston Medical Center (once Boston City Hospital) because he believes in the private, nonprofit hospital where he was born (and where he now serves on the board). He is chairman and CEO of Solomont Bailis Ventures, whose mission is to launch innovations in elder care. Other titles fit Alan equally. He's a philanthropist, a political fundraiser, and supporter of education and his alma mater, Tufts University.

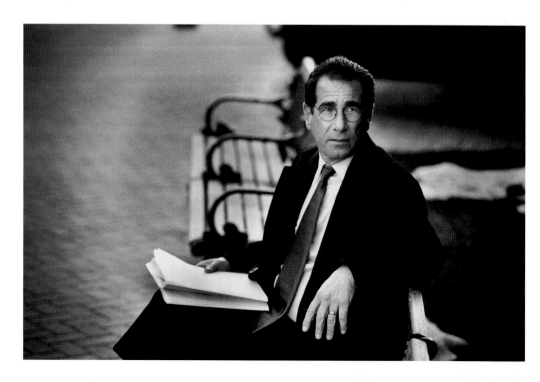

Serving as CEO of the John F. Kennedy Library Foundation is a fitting coda to **John Shattuck**'s 30-year career in government service and the nonprofit sector. An author and attorney, John was Harvard University's vice president for government, community, and public affairs for nearly 10 years. Appointed by President Bill Clinton as ambassador to the Czech Republic, in 2000 he received the Ambassador's Award from the American Bar Association's Central and Eastern European Law Initiative.

Not everyone in the stands knows their names, but there isn't a hockey player, or coach, or team in the area who hasn't heard of the Stewarts. The third generation of their family to keep order on the ice, **Paul Stewart** and his brother **Billy**, also are among the most charitable to wear black and white stripes—off the ice, that is. They are regular donors of memorabilia to local charities and have volunteered for many events.

From visionary to "the mayor of Jewish Boston" to philanthropic fundraiser, **Barry Shrage** carries more labels than anyone can track. In his 17 years at the helm of the Combined Jewish Philanthropies of Greater Boston, this Orthodox Jew has overseen the raising of $650 million. Barry is known for making the most of each moment of every day. And he's never known to have backed down from a challenge. One of the more repeated stories about Barry is how he lost 30 pounds on a challenge from his CJP board—and raised $60,000 in the process.

There has been a swirl of activity and growth around **Richard M. Freeland** since he took over the helm of Northeastern University in 1996. An American historian, Richard has spent his entire academic career in urban higher education, with both UMass Boston and later the City University of New York. For Northeastern to be recognized as the best and biggest school for practice-oriented (or as locals know it, "cooperative") education wasn't enough for Richard. He announced the university's intention "to be recognized among the top 100 national universities within the first decade of the 21st century."

Robert K. Sheridan, CEO of the Savings Bank Life Insurance Company, made sure that his portrait was taken with a photograph of the late Supreme Court Justice Louis D. Brandeis. Bob wants people to know that the idea of what is SBLI today was conceived by Brandeis and established in 1907 in Massachusetts. Savings Bank Life Insurance is now available through nearly 200 financial institutions in New England. Among the company's most notable sponsorships is the SBLI Falmouth Road Race, which is held every August.

Tina Shery's son, Louis D. Brown, would be 27 now. Struck down by a stray bullet while on his way to an anti-gang meeting, the West Roxbury High School honors student still inspires his mother and, through the foundation she started in his name, thousands of students in the Boston public schools. "There was only one way for me to do this. I needed to channel my anger. I just needed to figure it out," Tina said. The Louis D. Brown Foundation works with schools on anti-violence education and assists families who have been touched by violence.

Mark Semonian had an idea, and—like all good ideas—it was born out of finding a need and filling it. *The Improper Bostonian* was Mark's response to what was a "remarkable lack of anyone covering Boston's true nightlife." With the support of his family, he launched the magazine, which has now grown into a must-have for those looking to find out what's going on and how to plug into the scene. And Mark's timing couldn't have been more fortuitous: the biweekly magazine came into its own just as the Internet was taking hold. His sister, Wendy, now runs the publication and says of her brother: "I constantly find myself in awe that my brother had the foresight to conceive . . . something that is regarded as an important part of the fabric of our city."

If **Scott Solombrino** looks comfortable working out of the back of a limousine, it's because in his early days in the transportation business, he used his car as his office and his way to make money. Scott started his business as a way to pay off his Suffolk University education; he is now the president and CEO of Dav El Chauffeured Transportation Network. With a fleet of more than 12,000 vehicles in 550 cities worldwide, Dav El is the world's largest private limousine company. Known within his industry as a leader and advocate, Scott is active in the community in numerous organizations and is regarded as one of the most generous supporters of Boston's charities.

If Boston has anyone who could be called its "Observer," it is **John D. Spooner**. He's said to be the only investment adviser–novelist in the United States. A director of investments for a major firm, John watches over assets in excess of $700 million. He has written for a diverse array of publications, from *Playboy* to *Town & Country,* and has served as a contributing editor of *Worth* magazine. Active in numerous Boston causes, John was the creator of *A Book for Boston,* essays written in celebration of the city's 350th birthday. A former columnist for *Boston* magazine, John now writes for *The Improper Bostonian.*

When the city's most powerful and connected women hosted a luncheon for Senator John F. Kerry, it was state representative **Marie St. Fleur** who was asked to give the opening address. She wowed the nearly 2,000 attendees. The first Haitian American to serve in the state legislature, Marie is a lawyer (with a degree from Boston College), but it is her sheer ability to win people over that has made her most effective on Beacon Hill. A mother of three who never sought a life in politics, Marie has nonetheless been successful at the State House, where she serves as vice chair of the House Ways and Means Committee.

As chairman of the board of the Anthony Spinazzola Foundation, **Chris Spinazzola** combines his life-long interest and involvement in public service with his passion and expertise in the hospitality industry. But he's driven by something more. The oldest son of the late *Boston Globe* restaurant critic for whom the foundation was named, Chris and his family keep his father's spirit alive through programs to teach about and combat hunger and homelessness.

The story of Shields Health Care Group begins in 1972, when **Thomas Shields**, left, and his wife, Mary, opened Madalawn Nursing Home in Brockton. Troubled that their Madalawn patients had to be transported 20 miles to Boston hospitals for kidney dialysis, Tom and Mary (a nurse) opened the Brockton Dialysis Center in 1981. A few years later, as magnetic resonance imaging (MRI) began to replace x rays and CAT scans, the Shields family moved to bring improved medical care to the suburbs. Today Tom, Mary, their son, **Jack**, right, and other members of the Shields family run Shields MRI, which provides cutting-edge diagnosis to residents throughout the region. It is New England's original and premier independent MRI provider.

Nickolas Stavropoulos, president of KeySpan Corporation, which distributes natural gas in New England and New York, is equally at home in the office or in the field. You are as likely to see Nick in a hard hat visiting the street crews at night (especially during cold weather), as to see him in black tie celebrating one of his favorite charities, United Way of Massachusetts Bay or the Boys and Girls Clubs. The Cambridge native and Bentley College graduate is an accountant by training who came to work as an intern at the old Colonial Gas Company and then rose through the ranks.

A former state Commissioner of Mental Health, **Marylou Sudders** is now the president and CEO of the Massachusetts Society for the Prevention of Cruelty to Children, a private nonprofit organization with a legacy of strengthening families and preventing child abuse of the state's most vulnerable citizens. The organization works with an estimated 1,000 people a day, providing essential welfare and mental health treatment and effective public advocacy. In 2003, the Massachusetts Taxpayers Foundation gave Marylou the Manley-Ziegler Award, which is for state employees who "set the highest standard in serving the people of the Commonwealth."

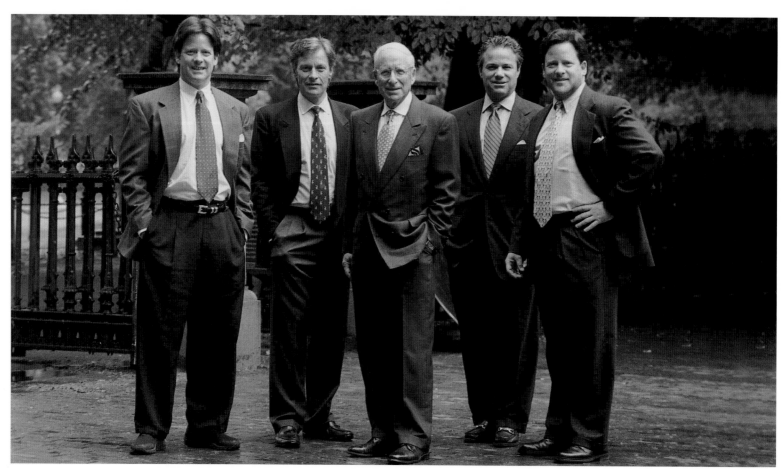

The title *hotelier* is something inherited in the Saunders family. **Roger Saunders**, center, with his four sons, **Todd**, **Gary**, **Jeffrey**, and **Tedd**, has carried on a tradition started by Roger's father, Irving. While you'll often find Jeffrey at the family's flagship property, the historic Lenox Hotel on Exeter at Boylston Street in the Back Bay, every member of the family is fully versed in the rich stories of the hotel and the details of the recent renovation. Although they are united behind the family tradition, their involvement in charities and causes ranges from the arts to the environment to education—and even to the local business community.

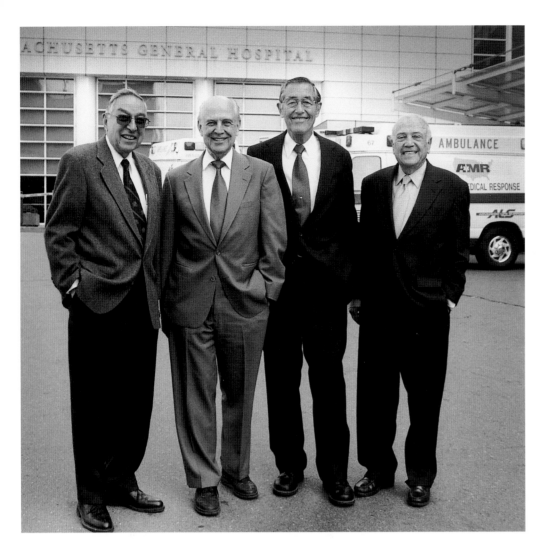

Boston's medical "Dream Team," these four physicians have transformed American medicine. All four came to Boston following World II and over the years have built practices, blazed trails, and served on national boards, helping establish Boston as the hub of the medical universe. Procedures, textbooks, and wings of buildings have been named in their honor. With more than 210 years of service and leadership in their fields, these physicians are **Dr. Morton N. Swartz**, infectious diseases; **Dr. John D. Stoekle**, primary care; **Dr. Roman DeSanctis**, cardiology; and **Dr. W. Gerald Austen**, surgery.

Josiah A. Spaulding Jr. has served as the general manager, president, and CEO of the Wang Center for the Performing Arts, one of the nation's leading cultural organizations, since 1987. During his tenure, Joe has established a nationally recognized outreach program, Suskind Young At Arts; completed an award-winning renovation of the Wang Center's technical systems and the refurbishment of the building's opulent 1920s architecture; and added the Shubert Theatre to the center's programming. Joe is the scion of a prominent Boston–North Shore family known for its philanthropic support of civic and arts causes.

In 1992, **Clayton H. W. Turnbull** secured exclusive rights to develop Dunkin' Donuts franchises for parts of Dorchester, Mattapan, Roxbury, and the South End—which launched the network of more than a dozen stores the Waldwin Group has developed. As CEO, Clayton's commitment to the business is evidenced by frequent visits to the stores. He serves on many boards and organizations, including Citizens Bank, Goodwill Industries, and Black & White Boston, and chairs the Neighborhood Housing Trust and Dimock Community Health Center Foundation Board. He was vice president of the 2004 Democratic National Convention in Boston.

A. Raymond Tye, founder of the Braintree-based beverage distributor United Liquors Ltd., is one of the most generous benefactors and philanthropists in the city. One business leader pointed out that it would be easier to list the organizations Ray *hasn't* helped out, and it's just a matter of time before he gets to those. The Ray Tye Medical Aid Foundation, established in 2002, might be his greatest gift and his best legacy. The fund pays for lifesaving medical treatments and surgeries for the "financially vulnerable individuals in our society," guaranteeing equal access to specialized procedures.

William O. Taylor is chairman emeritus of the Globe Newspaper Co., the company that published the *Boston Globe* until the newspaper and Affiliated Publications became part of the New York Times Co. in 1993. The fourth Taylor to become publisher of the *Globe*, Bill took over the title from his father, William Davis Taylor, in 1977. He has served as a trustee of the Boston Public Library, director of *Harvard* magazine, director of the International Center for Journalists, vice chairman of the Federal Reserve Bank of Boston, trustee of the International Crisis Group, and chairman of the Freedom Trail Foundation.

You may not be aware that they are on duty, and they are not the type to growl just to get attention. But the Boston Municipal Research Bureau's **Samuel R. Tyler**, president, and **Joanne Y. Jaxtimer**, board chair, are the city's watchdogs. The bureau is a nonprofit, member-supported research group established in 1932, when municipal oversight was unheard of in a politically freewheeling city like Boston. Sam became president of the bureau in 1983 and has been on the staff since 1972. Joanne is a senior vice president for Mellon Financial Corporation and director of corporate affairs for Mellon New England.

If you think the Boys & Girls Clubs of Boston are a place for youths to learn sports, you are right—but you're missing the other 90 percent of what young people do at clubs in Boston and Chelsea. As president and CEO, **Linda Whitlock** has expanded the programs and worked with her board of directors to undertake one of the largest capital fundraising campaigns in the country. With computer programs and technology training, career development programs, course offerings, visual and performing arts, as well as sports and recreation, the clubs provide more than 12,000 children and teens with places to grow and be safe.

When **Ellen Zane** was named president and CEO of Tufts–New England Medical Center and Floating Hospital for Children, she became the first woman to lead the institution in its 207-year history. Ellen assumed the position after years of running hospitals in the Boston suburbs (Quincy and Taunton) and programs that included Partners HealthCare System. Her charitable work has been similarly diverse, from smaller community-based organizations to the board of the John F. Kennedy Library and Foundation.

Henri A. Termeer is known as being an innovator on the cutting edge of the biotechnology industry. As chairman, president, and CEO of Genzyme Corporation, he has spent 20 years guiding his company's growth from a modest entrepreneurial venture into one of the world's top five biotechnology companies. Henri has an international reputation for his contributions to the biotech field and for his expertise in financing new initiatives. Active in the professional and academic communities, he has been recognized and honored by a variety of organizations, including the Anti-Defamation League's New England Region, which gave Henri its Torch of Liberty Award for his leadership in human rights and for promoting understanding among people of diverse religious, ethnic, and racial backgrounds.

Those books behind literary agent **John Taylor "Ike" Williams** are just some of the hottest-selling or groundbreaking works published in the past few decades. In many cases the works lining the shelves are the latest efforts of those Ike counts among his friends. Co-director of Kneerim & Williams at Fish & Richardson, the literary and dramatic rights agency he created, Ike recently received the Judge Learned Hand Award from the American Jewish Committee for his "defense of First Amendment rights, his dedication to civil rights, and his commitment to the arts community."

Since becoming the president and CEO of the Home for Little Wanderers in February 2003, **Joan Wallace-Benjamin** has made it her goal to "empower The Home to fulfill its mission of prevention, expert clinical care, outcomes research, and advocacy"—basically, anything that will make life better for those who pass through the famed Huntington Avenue facility. With her portrait taken in front of The Home's earliest advocates, Joan said she considers her position an honor and a challenge. With a doctorate from the Heller School for Social Policy and Management at Brandeis University, Joan previously served as the president and CEO of the Urban League of Massachusetts, director of operations for Boys and Girls Clubs of Boston, and deputy director of ABCD Head Start.

Kip Tiernan has given a voice to women in the region who wouldn't otherwise be heard, and she has put a face on the problem of homeless women in Boston. She founded Rosie's Place in 1974 and has tapped countless sources in the city to build the organization into the high-profile nonprofit that each year serves more than 64,000 meals and helps hundreds of women find emergency and permanent housing. Kip tirelessly raises money and awareness to ensure that Rosie's accepts no government funding in its pursuit of helping women "maintain their dignity, seek opportunity and find security in their lives."

As a former member of the New Kids on the Block, **Donnie Wahlberg** is a familiar name to most people. As an actor, **Neal McDonough** has been gaining a solid reputation in feature films and television shows for nearly 15 years. But the two, who date their friendship to their youth in Dorchester, never really had a chance to work together. Then came a critically acclaimed HBO mini-series, *Band of Brothers*, followed a year later by the NBC drama *Boomtown*. As this book was going to press, both were adding to their successes. Neal, who stars in the NBC drama *Medical Investigation*, was filming the movie *American Gothic*. Donnie had just finished shooting the movie *Annapolis* and was working on a TV pilot.

The vision of Roxbury Comprehensive Health Care Center's president and CEO **Anita L. Crawford** and board chairman **Ronald L. Walker II** (an executive vice president for Sovereign Bank) is what keeps the community health organization on track. "RoxComp," with an $11 million budget, has 200 employees at several sites in Roxbury and North Dorchester and provides 120,000 patient visits per year. Along with their fellow board members and the many supporters of the not-for-profit health care center, Anita and Ron just completed the first major renovation of RoxComp in its 30-year history.

He now commands a reported $10 million a movie, but there was a time when **Mark Wahlberg**'s future was uncertain. But not to **Rev. Jim Flavin**, a Catholic priest whom Mark credits with turning his life around. "The first time I met him I was 12 years old, and I was standing on a corner at three in the morning selling drugs," Wahlberg told a New York reporter a few years ago. "He has dedicated his entire life to doing God's work and helping people. Unfortunately, most of us didn't listen to him until it was too late. A lot of my friends are still in prison." The youngest of nine children, Mark was born and raised in Dorchester, where he got into a lot of trouble—including serving two months in the Deer Island Jail—before becoming a rap star and Calvin Klein model. He has since founded the Mark Wahlberg Youth Foundation, "established for the purpose of raising and distributing funds to youth service and enrichment programs."

Most people know **Richard J. Valentine** as the guy who owns F1 Boston, the indoor go-kart–racing facility in Braintree that's a favorite for team building among the corporate set. As a businessman who has also raced cars—at all levels—for more than 26 years, it would be easy to think of him as just that. But "RJ" isn't on one track. While working his way through Suffolk University, he couldn't afford a car, so he took a second part-time job (the first was in a slaughterhouse) driving for Town Taxi. He founded the Massachusetts Business Association more than 35 years ago when he saw that no one was serving the needs of small businesses in the state. The association has evolved into the largest provider of employee benefits, with more than 140,000 members. An entrepreneur who has started and run a multitude of companies, RJ developed dozens of Jiffy Lube service centers in Massachusetts and Rhode Island. His MBA Group is a conglomerate of 18 operating companies, covering "insurance, oil and gas, real estate, entertainment, and any business that we decide can produce bottom-line results."

The tenure of **Lawrence H. Summers**, the 27th president of Harvard University, has not been a quiet one. By mid-2005 he was working to repair his relations with Harvard faculty and students following fallout over remarks he made about women and their ability to excel in science. No one can question his credentials, accomplishments, and scholarship, however. An award-winning economist and author, he was a professor before serving as the U.S. Treasury Secretary during the Clinton administration.

To understand **Elaine Ullian**'s job as president and CEO of Boston Medical Center, you might want to look at a few facts. The famous campus in Boston's South End encompasses the former Boston City Hospital, the Boston Specialty Rehabilitation Hospital, and the Boston University Medical Center Hospital. When the merger was completed in 1996, it was the first full-asset merger of two public hospitals in the country. But Elaine doesn't just stay in her corner of town. She teaches at both the Boston University School of Public Health and the Harvard School of Public Health.

Liz Walker and **Jack Williams** had the serious task of handling the day's headlines each weeknight for WBZ-TV (now CBS4) for 18 years. But the two liked to have fun and always let the viewers in on the joke. Jack, who now anchors the noon and 4 p.m. newscasts, is best known for founding and supporting Wednesday's Child, which has helped nearly 500 special-needs children find permanent homes. After 25 years of working for the station, Liz recently scaled back to work more on the many causes she supports, including My Sister's Keeper, an organization she co-founded to support women in Sudan.

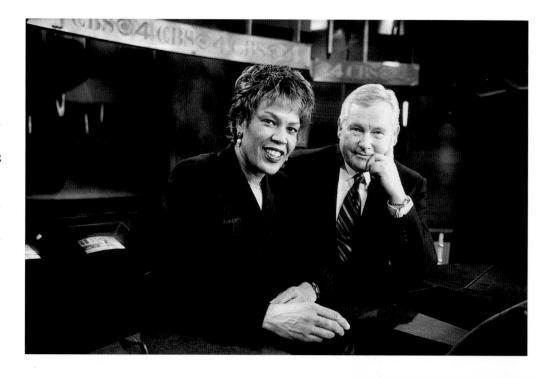

Richard L. Taylor, chairman of Taylor Smith Properties Inc., holds a Harvard MBA and a Harvard Law degree, making him one of the most sought-after people to serve on the area's many civic and charitable boards. But Darnell L. Williams, president and CEO of the Urban League of Eastern Massachusetts, is the lucky agency manager who has Richard's service and commitment. The nation's oldest and largest community-based movement, the Urban League was founded in the early 1900s as an organization devoted to empowering African Americans to enter the economic and social mainstream.

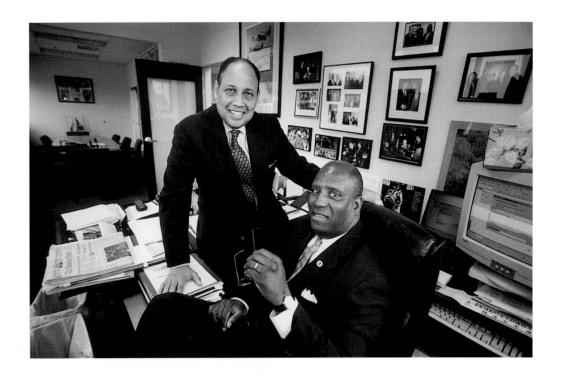

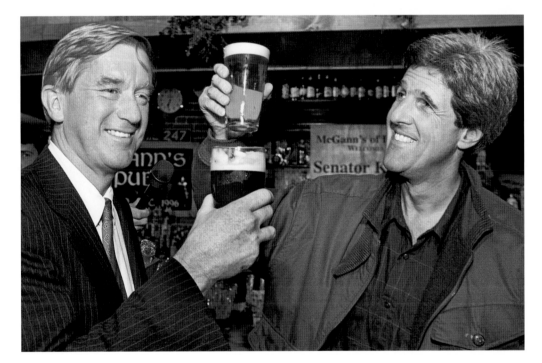

The debates and hard-fought campaign of the 1996 race for the U.S. Senate resulted in one of the closest votes in state history. Governor William F. Weld, a Republican, and Senator John F. Kerry, a Democrat, faced off in a grand display of old-fashioned Massachusetts politics. The two shared more than an ability to win over supporters: both were former prosecutors, both were immensely popular, and both had attended Ivy League schools (Bill, at Harvard; John, at Yale.) But when the votes were counted and John held onto his seat, the duo raised a pint together at McGann's, near North Station.

Vy Truong prepares for a case in the lobby of the Dorchester District Court. At the time this photograph was taken, Truong was the only Vietnamese American assistant district attorney in Suffolk County and was believed to be only the second person of Vietnamese descent to work as a prosecutor in the county. He is now in private practice in Dorchester.

A few months before the start of the 2004 Democratic National Convention in Boston, U.S. Senator **Edward M. Kennedy** appeared to know that the gathering would be a success and that it would help restore the city's image. But when he sat down in his Boston office for an interview for *Boston* magazine with David Nyhan, the former *Boston Globe* columnist (now deceased), many in the area doubted the convention would run smoothly. Ted, however, never wavered in his belief that it would be a great week for Boston.

The legendary Congressman **John Joseph Moakley** was a powerful figure in Washington, D.C., and even more so in Boston, but he wasn't a man of pretense. Family and friends ranked high on Joe's list, but there wasn't anything within his abilities that he would deny a constituent. After a political career that spanned 50 years, Joe died in May 2001, leaving behind a public legacy that may never be duplicated. The federal courthouse on the waterfront in his beloved South Boston bears his name, as does a field that is often packed with simultaneous soccer matches and baseball games in the warmer weather.

Historical accounts often state that a particular politician or leader built a community, but the 40,000 members of the building and construction trades unions who cover 24 communities in eastern Massachusetts literally have transformed the region, one building at a time. Eighteen union representatives stand before the new 790-room Westin Boston Waterfront, a hotel slated for completion by July 2006. The 18 business managers and representatives are, from left: **Rick Neville**, Carpenters; **Steve Uva**, Plasterers; **Bob Dicroci**, Cement Masons; **Mike Langer**, Elevator Constructors; **Martin Walsh**, Laborers; **Lou Rasetta**, Operating Engineers; **Ralph Harriman**, Painters & Allied Trades; **Jimmy Coyle**, Iron Workers; **Peter Gibbons**, Sprinklerfitters; **Joe Nigro** of the Building and Construction Trades Council; **Kevin Cotter**, Plumbers; **Fran Boudrow**, Asbestos Workers; **Joe Bergantino**, Sheetmetal Workers; **John Mahoney**, Teamsters; **Mike Monahan**, Electrical Contractors; **Dana Kelly**, Pipefitters; **Jerry Williams**, Boilermakers; and **Paul Bickford**, Roofers. The union reps gathered at the work site, which is adjacent to the Boston Convention & Exhibition Center, the largest building ever constructed in New England.

ACKNOWLEDGMENTS

I want to extend my gratitude and love to my wife, Ginnie, who has let me have the freedom to be who I needed to be; to my children, Kerry, "my second pair of eyes" Megan, Erin, and Tim; to my granddaughter, Morgan; and to my sons-in-law, Doug Hurley, John Khayali, and Corey Gunter. My brothers and sisters—Jack, Margaret, Mary, and Jim, and especially Harry—listened to me when I needed someone to lend me an ear and a laugh. Thank you for your unwavering support and patience.

Photo: Kerry Brett Hurley

A special thanks goes to David G. Mugar for believing in this project and giving me the encouragement that I needed. In addition, big thanks are due to RJ Valentine, who taught me never to lay off the gas and to keep pushing forward.

For teaching me the tools of the trade, my deepest gratitude goes to Don Bulman and Danny Sheehan, my first and finest teachers.

Many thanks to fellow photographers Paul Camello, Ted Gartland, Michael Hintlian, and Walter Van Dusen; and to Paul Benoit, Bob Dean, Jim Wilson, and last but not least Stan Grossfeld, who always saves the day.

In addition, I owe thanks to imaging technicians Jim Bulman, Susan Chalitoux, John Iovan, Kathleen Johnson, and Janine Rodenshiser; director of photography Paula Nelson and former director of photography Katie Aldrich; photo assistants Margaret Brett (my niece) and Justin Adomenus; and picture editor Leighanne Burton. I also must mention "Best in the Biz" Tom Mulvoy, Mike Barnicle, Ed and Bill Forry, John McDermott, David Nyhan, Mark Shanahan, and Susan Wornick. Robin Brown, Kevin Cotter, Elaine Driscoll, Peter Flaherty, Justin Holmes, Erin McDonough, Linda Noble, George Reagan, Dave Ting, and John Sasso made my life a lot easier. Bob Devine made parking on the streets of Boston possible.

And Carol Beggy: This book would not have come to fruition without you. My deepest gratitude for all your time and talents.

Bill Brett
May 2005